CW00566630

EDINBURGH WAVERLEY STATION

THROUGH TIME

Michael Meighan

This book is dedicated to all those who have made this book easier to write than I thought possible; all those who have dedicated themselves to recording life on the railways over the years. These enthusiasts have made a major contribution to recording and keeping our heritage alive.

First published 2014

Amberley Publishing
The Hill, Stroud
Gloucestershire, GL5 4EP

www.amberley-books.com

Copyright © Michael Meighan, 2014

The right of Michael Meighan to be identified as the Author of this work has been asserted in accordance with the Copyrights, Designs and Patents Act 1988.

ISBN 978 1 4456 2216 3 (print)
ISBN 978 1 4456 2232 3 (ebook)

All rights reserved. No part of this book may be reprinted or reproduced or utilised in any form or by any electronic, mechanical or other means, now known or hereafter invented, including photocopying and recording, or in any information storage or retrieval system, without the permission in writing from the Publishers.

British Library Cataloguing in Publication Data. A catalogue record for this book is available from the British Library.

Typeset in 9.5pt on 12pt Celeste.
Typesetting by Amberley Publishing.
Printed in the UK.

Introduction

In the 1980s, British Rail caused outrage throughout Scotland by deciding to rename Edinburgh's famous Waverley station simply as 'Edinburgh'. The rationale was that where there was only one principal station in a major town it would take the name of the town. The station was originally simply called 'The Waverley', not just by Edinburgh people, but by most Scots familiar with it. A compromise following a public outcry and a petition led to the name 'Edinburgh Waverley' coming into use.

The outcry demonstrates the esteem in which 'The Waverley' is held. From its earliest days it has established itself as one of Great Britain's iconic railway stations, and is held in high regard by the inhabitants of Edinburgh.

The station had strange beginnings, actually having been three stations, operated by three companies, which in time merged physically and financially into one, operated by the North British Railway Company.

Towering above the station, and just as iconic, is the Balmoral Hotel, originally built as the North British Station Hotel in 1902. Together with the North Bridge and Princes Street Gardens, these structures are at Edinburgh's heart.

However, while the North British Station Hotel was lavishly provided for over the years, the station was neglected. The North British was famed for its investment in the sumptuous hotel, but equally famed for its meanness when it came to investment in the station, which became overcrowded and virtually unmanageable, particularly with the growing passenger numbers created by the opening of the Forth Bridge. During Nationalisation and the 'Beeching Axe' of the 1960s, the station and lines suffered further lack of investment.

However, passenger numbers are growing, lines and stations are being opened, or reopened, and investment in Waverley has been extensive. The place is buzzing. New platforms as well as restoration of the buildings and replacement of the glass roof have brought new light into one of Scotland's gems.

This book records some of the changes and developments in the station and in the surroundings. These improvements have been a long time coming, and are welcomed by all.

Michael Meighan
March 2014

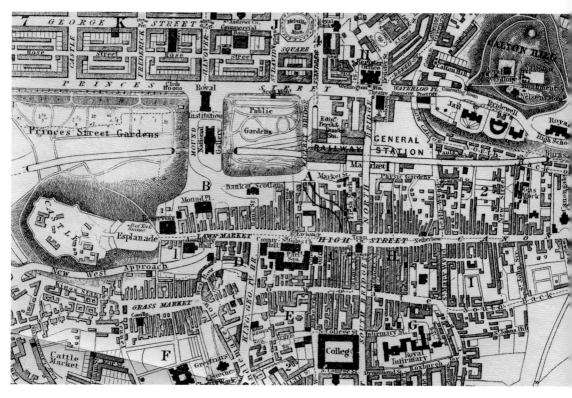

An 1858 map of Waverley station and surroundings. (Edinphoto)

The City of Edinburgh

It is the 'Athens of the North', Auld Reekie, and the capital of Scotland. It is the City of Edinburgh. It is also the home of the Edinburgh International Festival, the International Book Festival and the Festival Fringe. It has three universities. It is Scotland's financial capital, the home of two Scottish Premier League football teams – Hearts and Hibernian – and the home of Scottish rugby, Murrayfield. With around 470,000 people, it is the second-largest city in Scotland.

Edinburgh takes its history seriously and so it should. It has preserved its heritage with care, and its Old Town and New Town are, together, a World Heritage Site.

Anyone who walks from Holyrood Palace at the bottom of the Royal Mile up the long stretch to Edinburgh Castle will have trodden on the same high street as that in Edinburgh in the eighteenth century. Then, it was getting too big for itself. It was overcrowded, and without adequate drainage the citizens of Edinburgh would throw their night soil out of the window or door accompanied by the old cry of 'gardyloo', the corrupted French term for 'watch the water'. This excrement would slowly make its festering way down the hill to rest in the Grassmarket and in the Nor' Loch, which is now Princes Street Gardens and Waverley station.

The Nor' Loch was originally a marsh and a natural defence against invaders who might approach the town and its castle. To make it even more difficult to cross, in 1460 King James III ordered it to be flooded. As the old town became crowded during the Middle Ages, the loch became even more polluted with waste and rubbish. In 1763, the eastern end of the loch was filled in to allow the construction of the North Bridge.

In 1766 a competition was held for the design of a New Town that would reflect the ideals of an Enlightened Edinburgh; for beautiful architecture that would reflect on Edinburgh's position as a capital, a cathedral city and the home of a prestigious university, as well as the centre of a Scottish cultural renaissance.

British travellers pursuing their Grand Tour of Europe brought back sketches, paintings and sculptures from Rome and Athens and the ancient ruins such as the Coliseum, the Parthenon and the Acropolis. Published in national magazines, these images became the inspiration for a new classical architecture: neoclassical. Nowhere in Great Britain is this style more celebrated than in Edinburgh's New Town, which is the largest and most complete example of classical town planning in Europe. The Athens of the North had been born.

Part of this was to have gardens where the remains of the Nor' Loch existed. In 1820 the loch was drained for that purpose. There were originally two sets of gardens: the East and West Princes Street Gardens. While the Edinburgh Corporation had acquired the land at the east end, actions were raised by the New Town proprietors, who objected to building on the land. This prolonged dispute eventually resulted in the Corporation being allowed to build on the area presently occupied by Waverley, the Balmoral Hotel and Waverley Market. On the other hand, while ongoing building could be completed, further building was limited to below street level. That is why the Waverley station buildings remain in a valley and why any moves to build above are swiftly killed off.

Into all of this came the railway, nestling between the Old and the New Town. The Edinburgh & Glasgow Railway Company, whose Edinburgh terminus was at Haymarket in the west end, wanted to reach the North British General station at Waverley. In 1846 they built their railway, sunk at the bottom of the gardens, and reached Waverley through two tunnels, one at the west end under Lothian Road and one under the Mound between the East and West Gardens.

James Craig was the architect who, in 1766, put forward, in competition, designs for the New Town. While much of it was put into practice, one thing that was not was an ornamental canal where the railway is now, at the foot of the gardens, with pleasant walkways on either side. While the idea was not taken forward, a street, where the Waverley Market stands, was named after it, and Canal Street was to be where the Edinburgh, Leith & Newhaven Railway Company was to site its new station.

There was also another, possibly more useful scheme, put forward by Robert Stevenson in 1817. This was to be an extension to the Forth & Clyde Canal. One possible connection would be made from around Falkirk and proceed from Haymarket through a basin at North Bridge and thence via the Canongate to the Forth at Leith. This project never came to fruition.

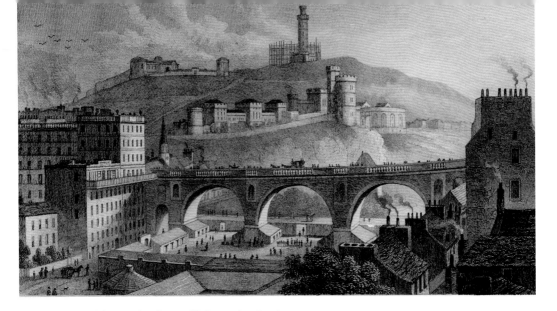

North Bridge and Calton Hill from the Castle
This 1829 engraving by Thomas Hosmer Shepherd shows the North Bridge prior to the building of the railways. Shepherd was an accomplished artist and architectural illustrator who recorded scenes in London, Edinburgh, Bath and Bristol. His attention to lifelike detail helps us understand day-to-day life in Georgian and Victorian Edinburgh. Here we can see carriages on the bridge and activity below. The bridge was later widened by using parapets that were fixed by large iron bars pushed though the narrow arches between the main ones. This can be seen in later photos in the book.

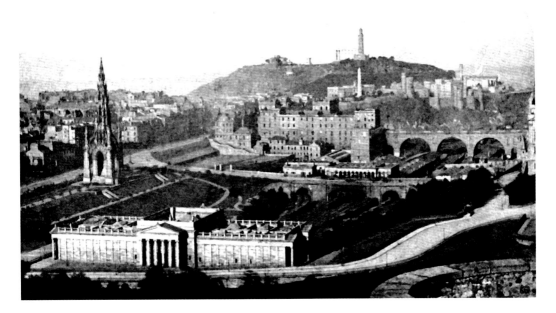

North Bridge from the Castle
This is a rare photograph of the railway before the closure of Canal Street station. In the centre of the image you can see railway carriages entering and leaving the arch under Waverley Bridge leading to the Canal Street platforms.

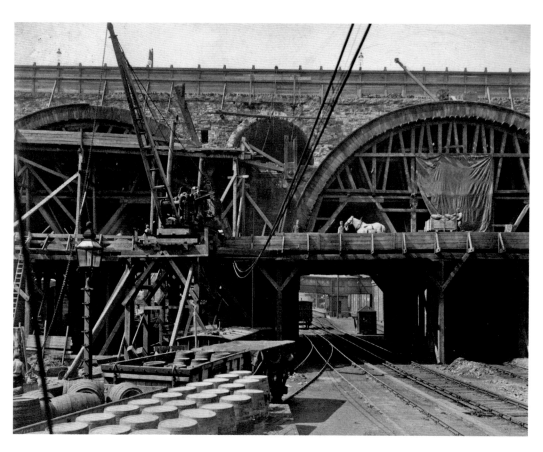

Demolition of North Bridge in 1896
This is a very detailed view of the methods of demolition; a steam crane is in operation. (Blyth & Blyth)

The Growth of the Railways

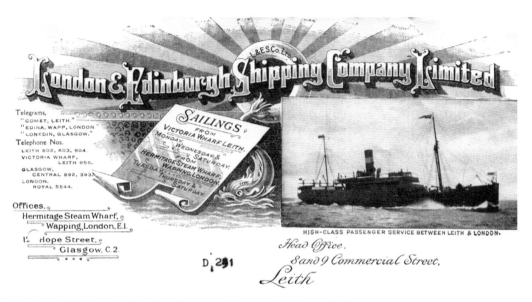

London & Edinburgh Shipping Company, Commercial Street, Leith.

Modern folk who travel around Scotland and beyond might complain about the traffic hold-ups, about train breakdowns and delays, and about cancelled flights. If they lived over 100 years ago, the biggest complaint would have been the state of the roads, in that there were no roads to speak of. When Queen Victoria ascended the throne in 1837, there were still very few railways in Scotland, and those that existed were mainly for the transportation of goods and raw materials such as coal from the mines of Fife, West Lothian and Lanarkshire.

Before the railways, local travel was on poor roads and by horse or by stagecoach. For longer distances or for speed, the sea was the only option. People from the north of Scotland who wanted to travel to Edinburgh would do it by sea as it was the quickest method. The same would be true of travel between Edinburgh and London.

This gave opportunities to Scotland's entrepreneurs, who were ever ready to seize on a profitable venture. They established a great

merchant fleet that plied the waters round our shores just as if they were today's motorways. The seas were teeming with ships. Typical of the coastal trade was the London & Edinburgh Shipping Co., based in Leith. The company, set up around 1809, carried a wide variety of cargo, and it was the company's clipper *Isabella* that made history in Scotland by being the first ship to bring into any port, apart from London, a cargo of tea. This was in 1833, following the end of an importation monopoly held by the East India Company. The tea was destined for Andrew Melrose & Co., set up in 1812 and still going strong as a brand of Typhoo tea.

Just before the First World War, a first-class ticket to London from Edinburgh on the 'first-class steam ships' – the *Malvina*, the *Marmion*, the *Iona* or the *Morna* – would have cost you 22 shillings, with provisions from the steward 'on moderate terms'. The 1,244-ton *Malvina* was sunk by German submarine *U-104* on 3 August 1918, about a mile from Flamborough Head. Fourteen souls were lost. The submarine was believed to have been destroyed by depth charges from an armed yacht.

With the growth of the railways, the passenger trade between Leith and London declined, and stopped altogether during the war years. Following the Second World War the company went into decline, and liquidation followed in 1964.

In the same way that modern trains are opening (or reopening) access to towns and villages throughout Scotland, the railways were to bring the counties of Scotland closer as well as bringing London and the industrial parts of England ever nearer. With the coming of the First World War, they were to become an essential part of the war effort.

It was with this background that Waverley station came to Edinburgh. Although we now look on Waverley as one station, in fact the original incorporated three distinct stations that were eventually amalgamated into one entity. We will look at these in turn after we have a look at the setting into which they were built.

Around Waverley

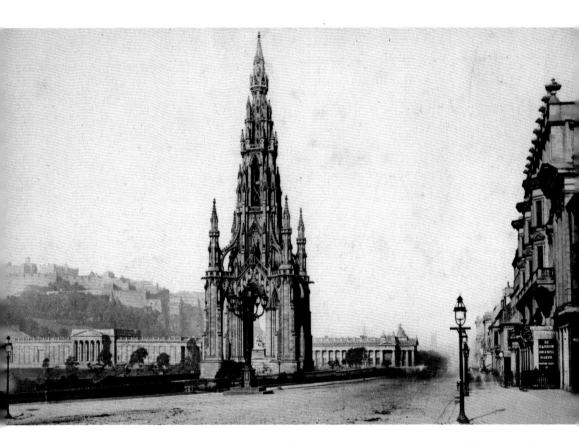

Princes Street and the Scott Monument, sometime between 1859, when the National Gallery opened, and 1871, when the trams first began.

Sir Walter Scott was a highly influential and respected Scottish novelist whose works were read throughout the world in the nineteenth century. He was our first bestselling international author, and many of his works are still read and considered classics. The Waverley Novels include *Rob Roy*, *Ivanhoe* and *The Heart of Midlothian*. The names of many of Scott's characters were given to the locomotives of the North British Railway and, of course, 'Waverley' became the name of the station.

After Scott died in 1832, a competition to design a memorial to him was won by George Meikle Kemp. The finished memorial included a statue of Scott between the four columns. The white Cararra marble figure designed by John Steele shows Scott with a quill pen and paper and his dog Maida at his side.

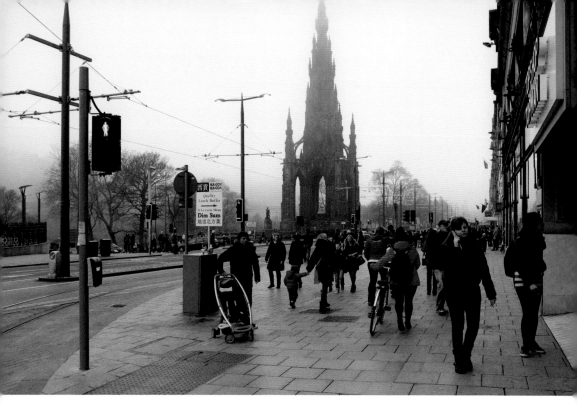

Princes Street and the Scott Monument, 2014.

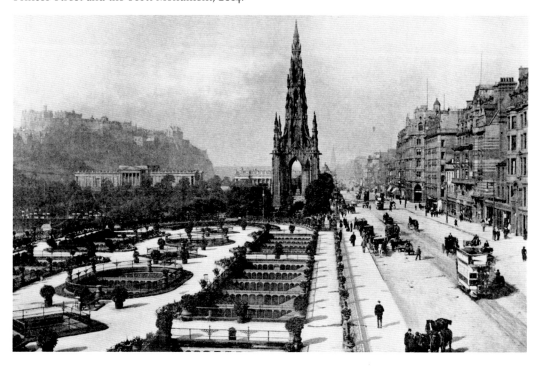

Princes Street looking west.

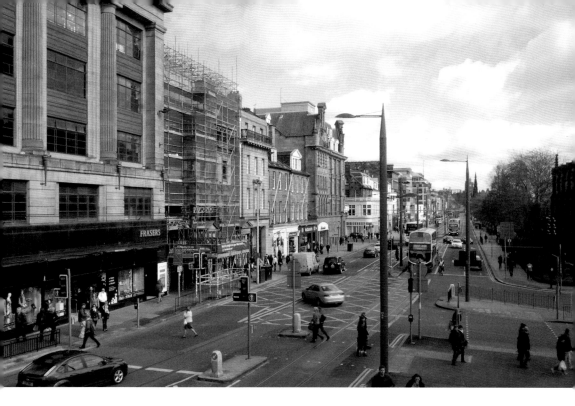

Princes Street towards the east.

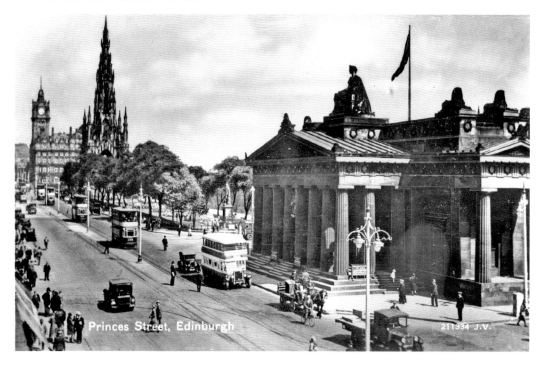

Princes Street, Edinburgh

211334 J.V.

Princes Street and William Henry Playfair's Royal Scottish Academy, which was called the Royal Institution from 1826 to 1911. The statue of Queen Victoria as Britannia was added in 1824.

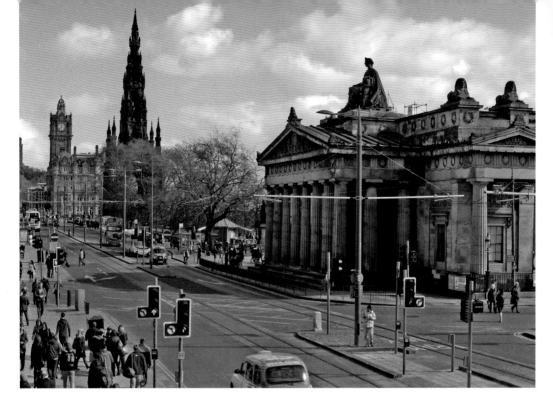

A lovely spring day on Princes Street, 2014.

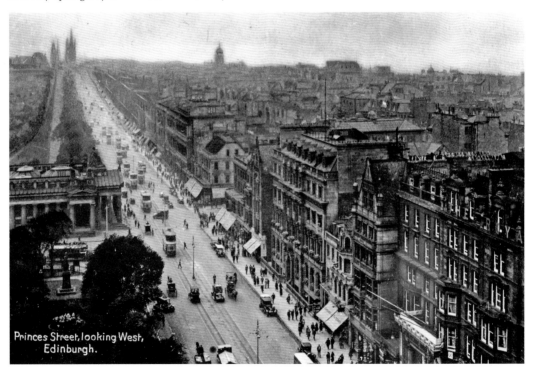

Princes Street, looking West, Edinburgh.

Princes Street looking west.

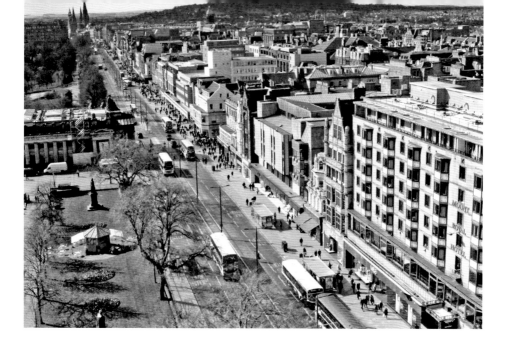

Down to the right you can see Romanes & Paterson's Scottish shop, which is still where it was in Edwardian days.

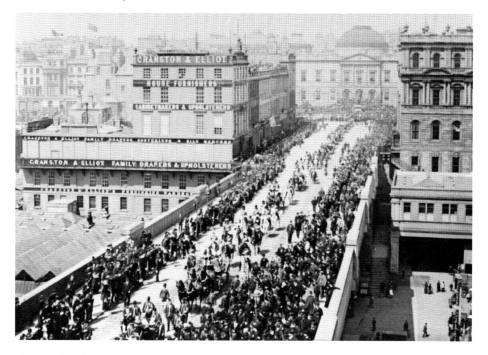

The Lord High Commissioner's Procession on the North Bridge
This is the procession of the British sovereign's personal representative to the Church of Scotland. The role of High Commissioner has been in existence since 1690. In this early glass slide, you can see the activity on the circulating area of the North Bridge station underneath. It had a stairway down from the bridge. This would be before around 1896, when Cranston's department store, to the left, disappeared to make way for the North British Railway Hotel.

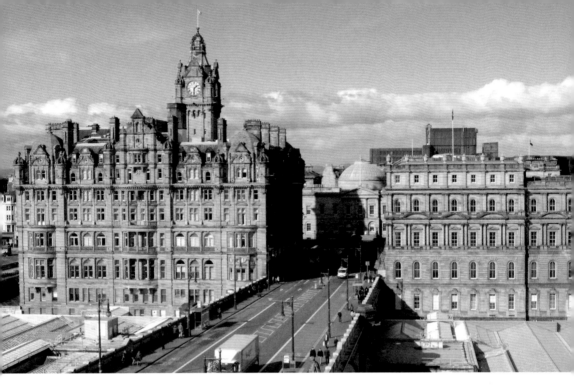

The modern version, with the Balmoral Hotel replacing Cranston's.

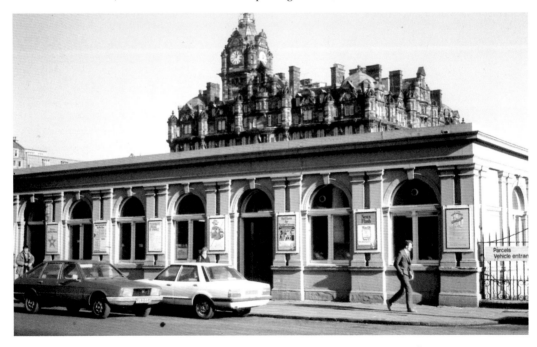

When this photograph was taken by Michael Patterson, the building was the Red Star parcel office. It is the only remaining part of the original North British station. The building has been considerably remodelled since it was first built, when it was surrounded by a railing. This can be seen in the George Washington Wilson image later on.

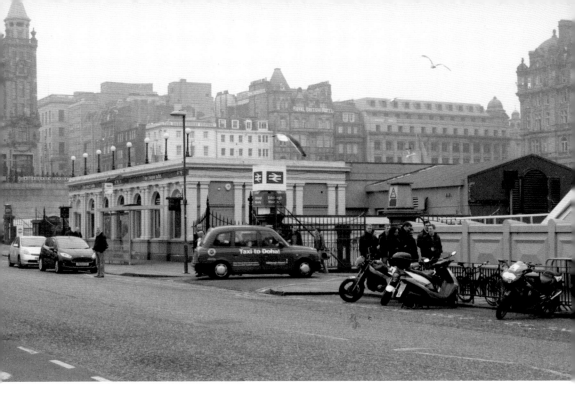

Jimmy Chung's restaurant, soon to be a Wetherspoon's. Princes Street is in the background.

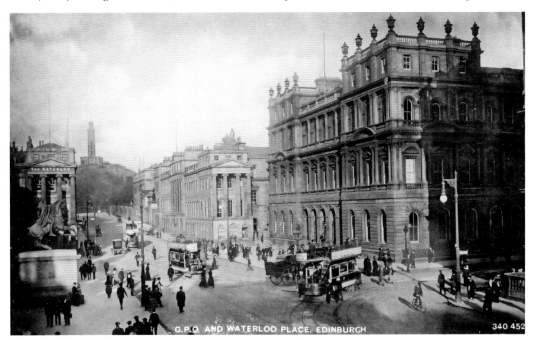

The General Post Office and Waterloo Place
Work on the GPO began in 1861, when the foundation stone was laid by Prince Albert. The building was designed by HM Office of Works architect Robert Matheson.

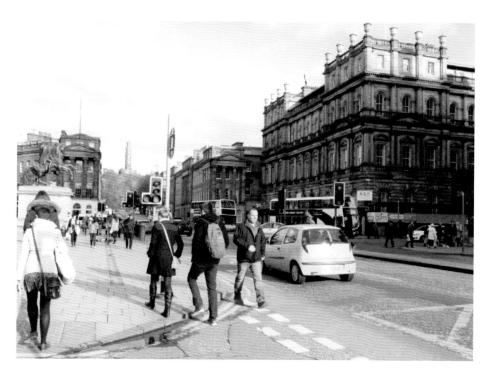

The GPO was extended in 1891 and 1907. It closed in 1995 but was redeveloped and reopened in 2000 as offices, gyms and a restaurant.

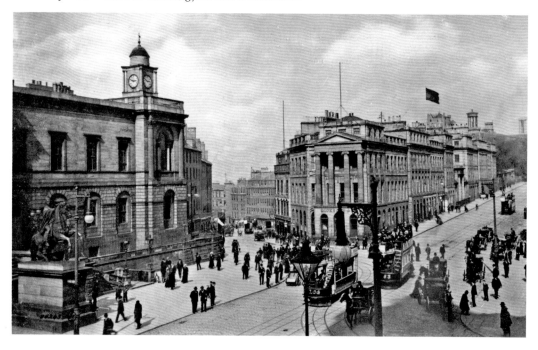

From left to right: Register House, Leith Street and Waterloo Place, Edinburgh.
Compared to the opulence of the North British Hotel, the headquarters of the North British Railway Company was in an unassuming building, at No. 23 Waterloo Place.

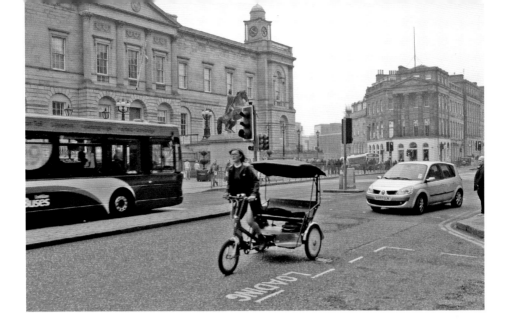

Modern times!

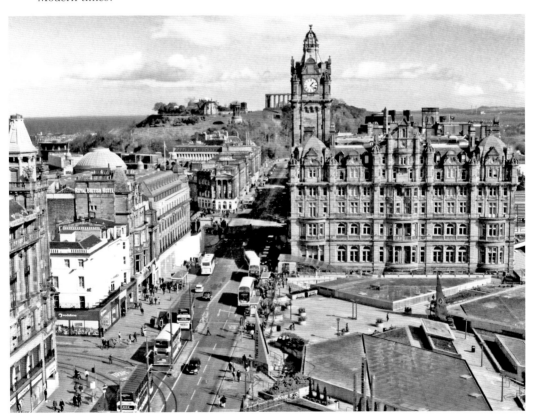

Towards Calton Hill from the Scott Monument. Cockenzie power station is in the distance, on the East Lothian coast. At the bottom right is Princes Mall, which replaced Waverley Market.

19

Waverley Bridge

On a dreich day, pedestrians cross Princes Street from Waverley Bridge. Within the market building is being held the *Scottish Daily Mail* Ideal Home Exhibition. (A. Hailstones)

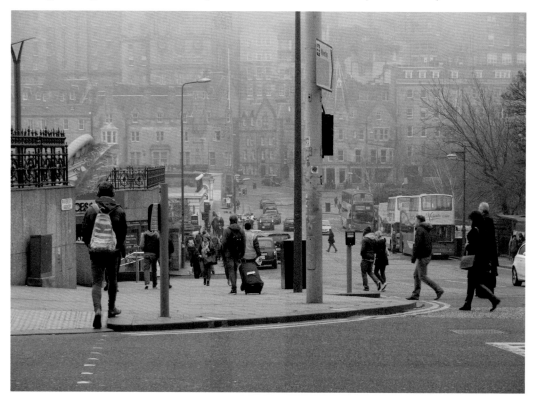

March 2014. It's not always so dreich, honest!

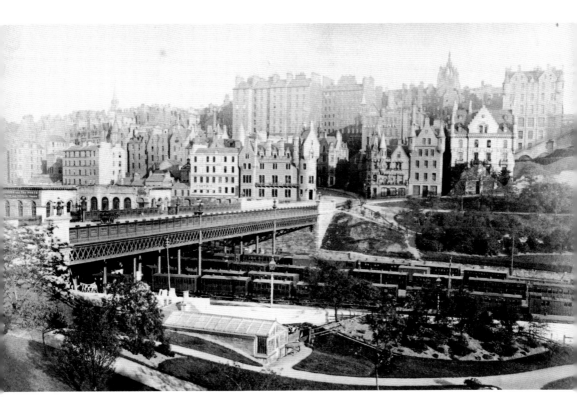

George Washington Wilson's study of the Old Town and Waverley Bridge.

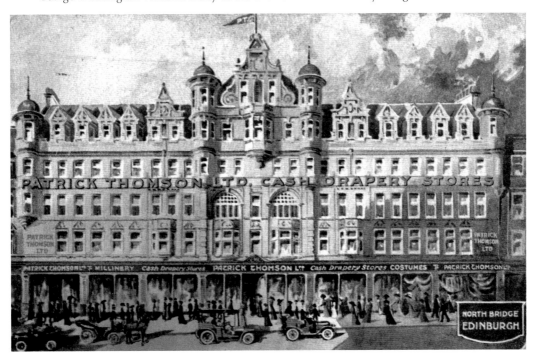

Patrick Thomson's was a long-established department store on North Bridge.

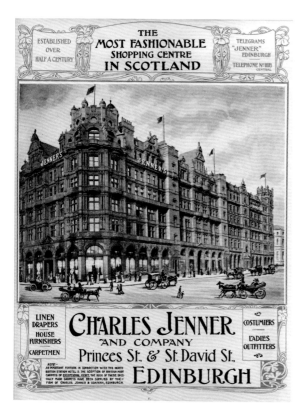

ESTABLISHED OVER HALF A CENTURY

THE MOST FASHIONABLE SHOPPING CENTRE IN SCOTLAND

TELEGRAMS "JENNER" EDINBURGH

TELEPHONE No 1118 CENTRAL

LINEN DRAPERS

HOUSE FURNISHERS

CARPETMEN

COSTUMIERS

LADIES OUTFITTERS

CHARLES JENNER AND COMPANY

Princes St. & St. David St.

EDINBURGH

NOTE. AN IMPORTANT FEATURE IN CONNECTION WITH THE NORTH BRITISH STATION HOTEL IS THE ADOPTION OF BRITISH MADE CARPETS OF EXCEPTIONAL MERIT, THE BULK OF THESE SPECIALLY MADE CARPETS HAVE BEEN SUPPLIED BY THE FIRM OF CHARLES JENNER & COMPANY, EDINBURGH.

Left: Charles Jenner & Co., another famous department store, opposite the Scott Monument.

Below: The Carlton Hotel has taken over most of what was Patrick Thomson's department store. The ground floor now has shops and restaurants.

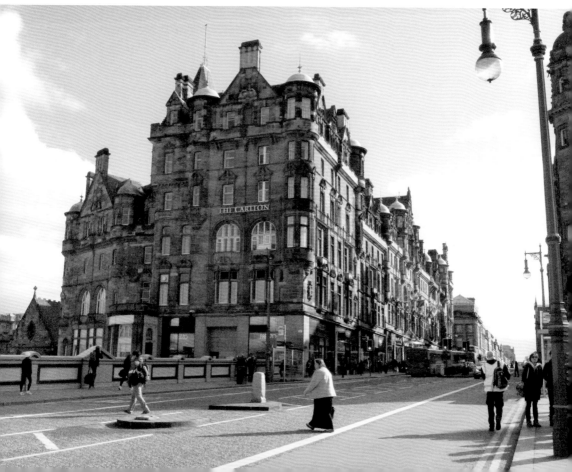

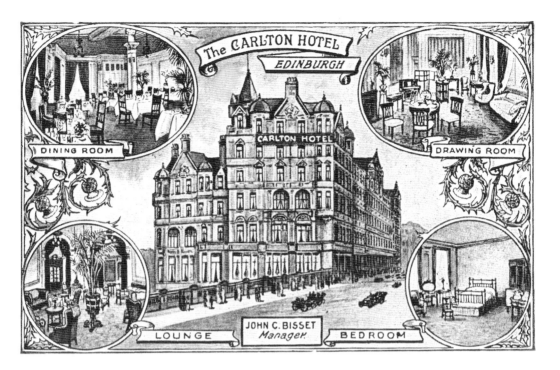

The Carlton Hotel on North Bridge.

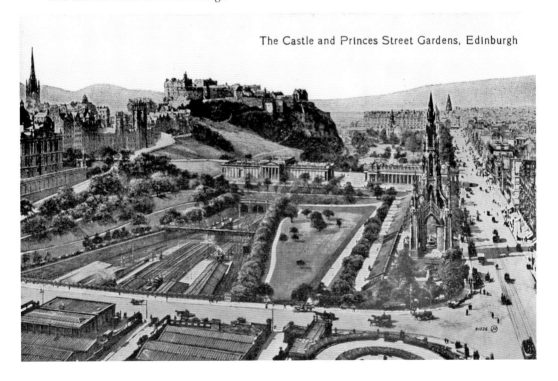

The castle and Princes Street Gardens.

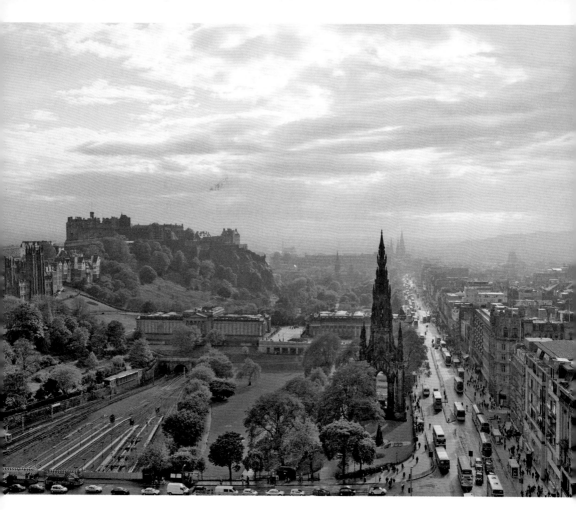

A modern view from the Balmoral Hotel. (Balmoral Hotel)

Edinburgh Waverley Station

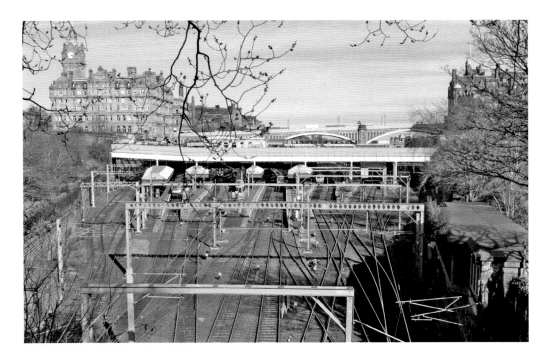

Waverley from the National Galleries, 2014.

The North British Railway (NBR) was not the first to serve Edinburgh; that was the privilege of the Edinburgh & Dalkeith Railway, or 'The Innocent Railway'. This route opened in 1831, initially using horses to haul coal wagons from pits around Dalkeith to St Leonards, south of Arthur's Seat. The 'Innocent' title supposedly refers to the fact that nobody was killed or injured in its construction – a likely story!

The railway was built by a consortium of mine owners to get their coal into Edinburgh. In 1832, a private enterprise started carrying passengers. In total, the network, enlarged by many tramways going off to mines and a branch line to Leith, covered around 12 miles.

Around 1840 there were plans for extending the railway and using steam locomotives. However, the North British Railway Company (NBR)

was bigger and had grander ambitions. In 1845, it purchased the line to allow it to reach Carlisle from Edinburgh. While much of the line became redundant, a part of it became what is known as the Waverley Route.

The NBR was a scheme put forward by promoters to link Berwick with Edinburgh. They obtained consent by Act of Parliament in 1844 and work started. The line was completed in 1847 and, with a link to the York, Newcastle & Berwick Railway in August 1850, Edinburgh was joined to London by rail.

We have to bear in mind that in the railway boom, railways were built in a frenzy of investment, with unrealistic expectations of high returns. The problem was that many of these lines were local and short, often joining mines and quarries to harbours or towns. The ambitions of bigger players with a national vision were often thwarted by fragmentation. These bigger ambitions created mergers and acquisitions and a behemoth system that was to last until nationalisation in 1948 and the Beeching Axe of the 1960s.

The NBR was based at 23 Waterloo Place in Edinburgh. As it expanded, it acquired over twenty local railway companies. It operated Clyde steamers and built the North British Station Hotel at No. 1 Princes Street, which we will hear about later. The company's North Bridge station in Edinburgh was opened in June 1846.

Around the same time as the NBR was being formed, a proposal was put forward to link Edinburgh and Glasgow. With the speed of such things at the time, the railway from Queen Street (or Dundas Street as it was called then) to Edinburgh's Haymarket took only four years from the Act of Parliament in 1838 to be completed, and opened in 1842. There were four trains each day, and the journey took 2½ hours. Branch lines were then acquired or opened to a number of places such as Bathgate, South Queensferry and Helensburgh.

In 1846, the Edinburgh & Glasgow Railway Company (E&G) line was taken along Princes Street Gardens, and burrowed under the Mound to meet the North British North Bridge station at its own station, the 'General', opened in 1847.

The third company was the Edinburgh, Leith & Newhaven Railway, whose line was built particularly to service the ports of Edinburgh, carrying passengers to the ferries and steamers at Leith, Newhaven and then Granton, when it was renamed the Edinburgh, Leith & Granton Railway. The ELNRC started their horse-drawn railway in August 1842 with a line from Canonmills to Newhaven station, to the west of Leith, north of Edinburgh. Canonmills station later became Scotland Street station, and a tunnel was driven from here in 1847, under the city to a

new Canal Street station. The new station was beside the North Bridge station and at right angles to it.

An entrance in the wall of Waverley station shows the rough location of the original tunnel entrance. The small portico actually houses a ventilation shaft, which is still complete and of which internal photographs can be seen, taken by urban adventurers.

The tunnel is 1 km long, descending in a gradient. Trains were moved by cable haulage, with two men operating handbrakes in the front wagons. Carriages proceeding up the gradient to Canal Street station were hauled by a stationary steam engine. The name of the station was changed to Princes Street station. This has caused some confusion, as the Caledonian Company's station at the west end of Princes Street was given the same name, although it was always referred to as 'The Caly'.

However, the tunnel only existed as a railway route for around twenty years. In July 1862, the company was taken over by the expanding North British, who closed the tunnel in 1868. They had an alternative route to Newhaven.

With the three railway companies occupying adjacent sites, it was natural to combine these in one, and Waverley station was created in 1854.

With the acquisition of the Edinburgh & Glasgow Railway in 1865, Waverley effectively became a unified station. The North British had

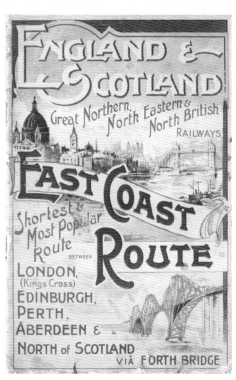

East Coast Route Brochure. (Mike Ashworth Collection)

complete control of the station and was Scotland's largest railway company. It rebuilt Waverley between 1892 and 1902. It also built the new Tay Railway Bridge and, with other companies, the great Forth Railway Bridge. This was the situation until the railways were grouped together to form the 'Big Four', with the NBR becoming a part of the London & North Eastern Railway Company (LNER).

Before the First World War there were around 120 individual railway companies, mostly making losses and in competition with one another. During the war these were brought together under state control, which lasted until 1921. While full nationalisation was considered, the solution adopted was one designed to minimise competition while maintaining some of the economies of scale found during the war. In 1921 the Railways Act brought together most companies in a grouping that resulted in the LNER, the London, Midland and Scottish (LMS), the Great Western Railway (GWR), and the Southern Railway (SR). It was *Railway Magazine* that gave them the name 'Big Four'.

Full nationalisation was achieved by the Government following the Second World War, when the Transport Act of 1947 formed British Railways (BR). This was to be known as British Rail from 1965, and would be up until railway privatisation between 1994 and 1997.

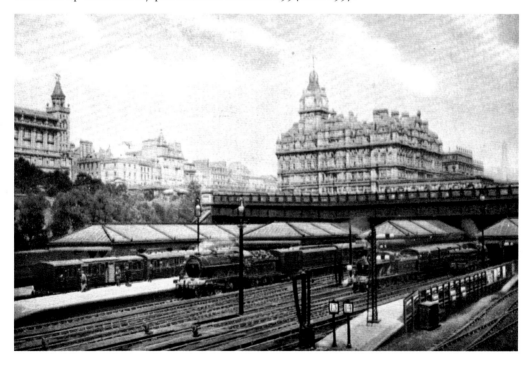

Waverley station and the North British Hotel.

The tenure of British Railways saw the massive changeover from steam locomotives to diesel and electric, and a move away from freight to passengers. It also saw the reduction by 30 per cent of the railway network by Dr Beeching in the 1960s. His report for the British Railways Board in 1963, *The Re-shaping of British Railways*, paved the way for the 'Beeching Axe', which closed almost 2,400 stations.

The railway network was faced with growing competition from road transport, particularly with the growth of motorways and use of cars. His report was intended to stem losses by reducing the overheads of underused stations and routes while investing in major lines and containerised freight.

His cuts produced national protests, some resulting in routes remaining open. Lines from Waverley suffered as badly as others. Routes to the Borders were cut, as were local services to Bathgate and Corstorphine. On the other hand, with the growing use of railways, some of these routes have reopened or there are plans to reopen them. These changes have once again put Waverley station at the hub of transport services in the city and made it a bustling transport centre.

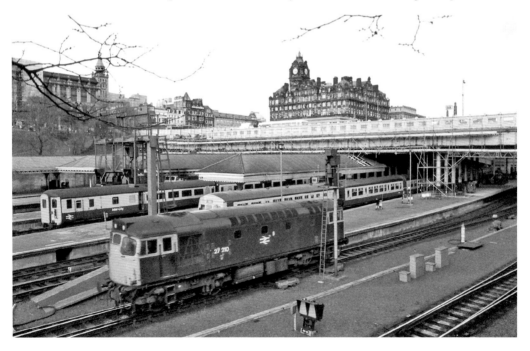

No. 27210 in March 1984, about sixty years after the postcard image.
The Class 27s were built by the Birmingham Railway Carriage & Wagon Co. between 1961 and 1962. No. 27210 moved to Haymarket shed in 1971 and was scrapped in 1987. Beyond, on the left, is a Driving Brake Standard Open (DBSO) (more information on this later). (David Ford)

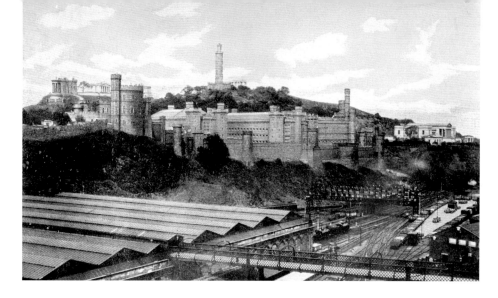

Calton Hill with Waverley underneath, showing the once existing walkway from Calton Road through to Jeffery Street, crossing Market Street in the process. An unsuccessful campaign was launched in 1999 to re-establish the link, which was temporarily closed in 1950 but never reopened. When the station was rebuilt in 1892, it displaced a busy route, Leith Wynd, and a condition of the rebuilding was the creation of a replacement route. Until the station was recently reroofed, the walkway still existed within the station. The walkway entrance can still be seen in Calton Road. A friend of mine who lived at the top of Leith Walk said that they called this footbridge 'The Shoot', as they could 'shoot through' to the Old Town!

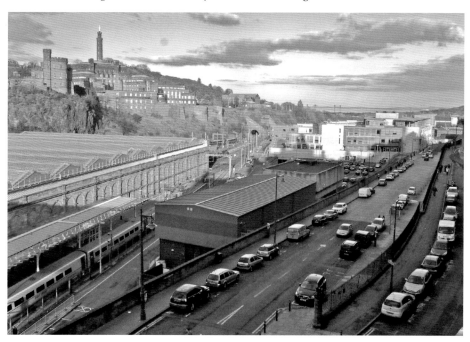

A view from North Bridge. The goods yards have gone, to be replaced by Edinburgh Council headquarters. The square grey concrete building is the central signalling control centre, which replaced many signal boxes in the 1980s.

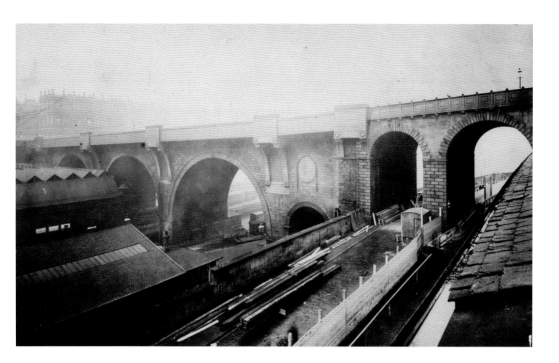

Old North Bridge from above Market Street, being prepared for demolition. What a tidy site!

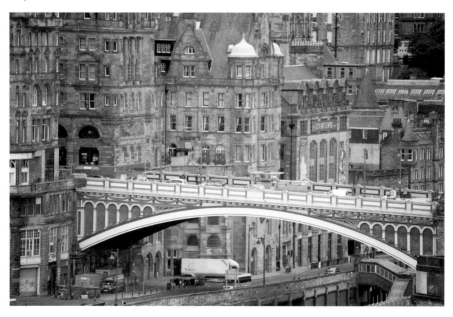

The new North Bridge from Calton Hill, 2011. The Market Street entrance is yet to be renewed. The iconic *Scotsman* buildings have become a hotel. (Richard Collins)

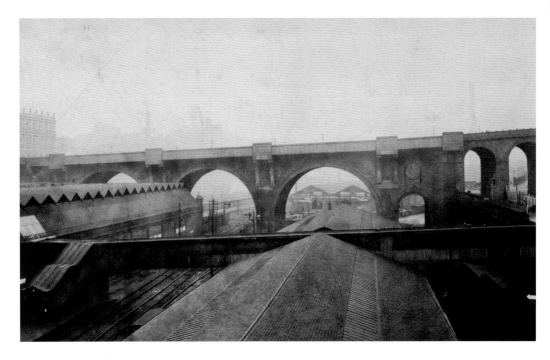

Old North Bridge
On the left you can see the 1847 North Bridge station, which was covered by a transverse ridge and furrow roof, which was 300 feet wide by 1,100 feet long and was designed by the engineers Blyth & Cunningham of Edinburgh. (Blyth & Blyth)

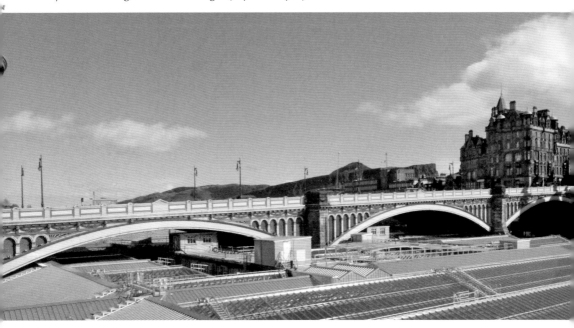

The new North Bridge and the new station roof.

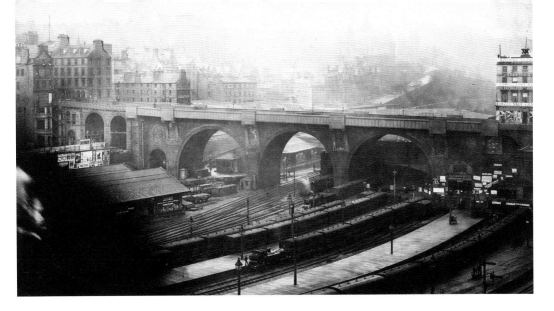

Old North Bridge in preparation for demolition. The North British terminus can be clearly seen, with the telegraph office under an arch. As there is no traffic on the bridge, I suspect that it had already been closed off.

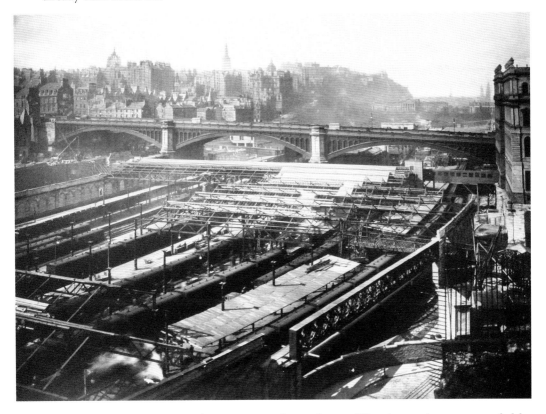

The new North Bridge is in place. Between 1892 and 1900, Waverley station was extended by Cunningham, Blyth & Westland. At the bottom right of the picture, you can see the enormous girder allowing access to the station for GPO and other goods vehicles. (Blyth & Blyth)

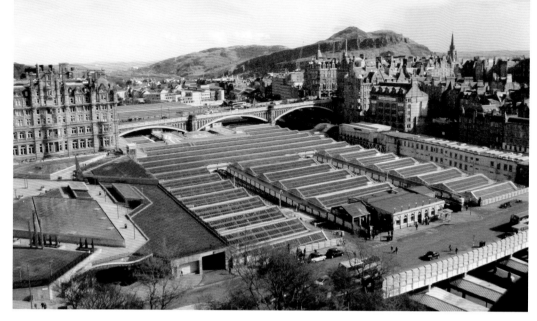

Waverley station from the Scott Monument, with Arthur's Seat in the background.

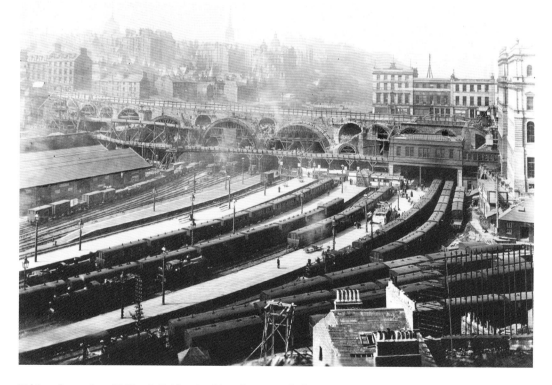

Taking down the old North Bridge, looking downwards from Regent Road. This is around 1896, when the old North Bridge was demolished to allow the building of the new. The demolition took place to allow the station to continue working. A gallery has been erected, and horses and carts go back and forwards carrying the old stonework. To the right is the General Post Office, erected in 1866. (Blyth & Blyth)

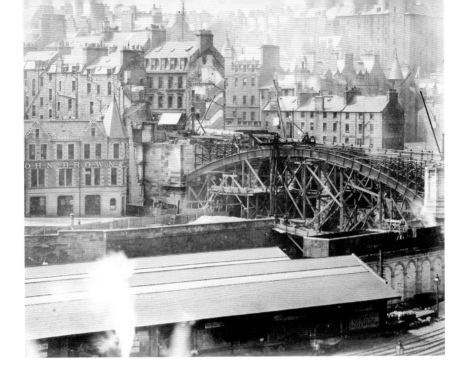

North Bridge under Construction

Blyth & Blyth is a long-lasting and reputable Scottish company, still based in Edinburgh. As Blyth & Westland they were the consultants for the new three-span iron and steel North Bridge, which was built between 1896 and 1897.

Blyth & Blyth had its origins in Benjamin Hall Blyth's civil engineering practice in 1848. They were substantially involved in road and rail infrastructure, and this included Edinburgh's Waverley station as well as Glasgow Central station.

Benjamin Hall Blyth Junior was apprenticed to his railway engineer father in 1867 after receiving his MA at Edinburgh University. He became a partner in 1871. On his father's death in 1866, the firm was being run by David Munro Westland and George Miller Cunningham, under the name of Cunningham, Blyth & Westland. At the retiral of Cunningham in 1893 it became Blyth & Westland, taking the present name Blyth & Blyth when Westland retired in 1913. (Blyth & Blyth)

'Like the wind at the top o' the Waverley Steps' is a well-known saying. The wind is funnelled through the station and becomes a hurricane in what is a rather small exit, sweeping people off their feet as they pass.

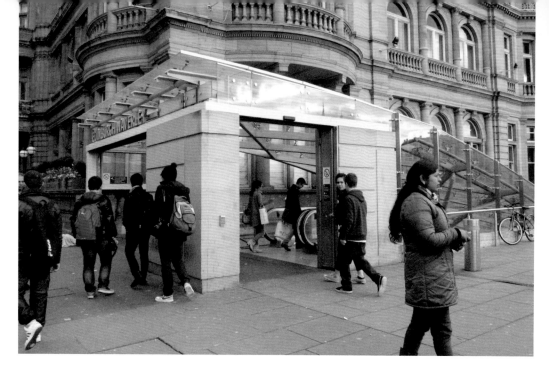

Well protected against the wind and with new escalators, too.

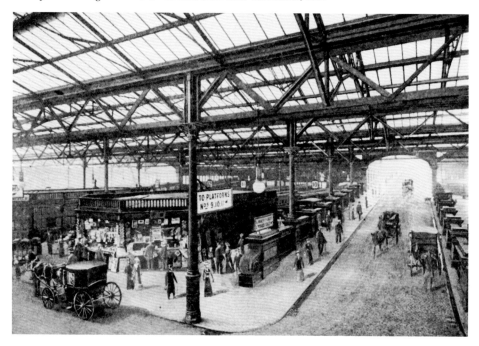

Station entrance and circulating area, *c.* 1902, with John Menzies' bookstall.

John Menzies was an institution in Scottish stations and high streets. The bookstall concession was won in 1862, and this one was still in the same position in 1960. Menzies, established in 1833, is still based in Edinburgh. Menzies sold its shops to WH Smith in 1998 to concentrate on newspaper distribution and aviation services.

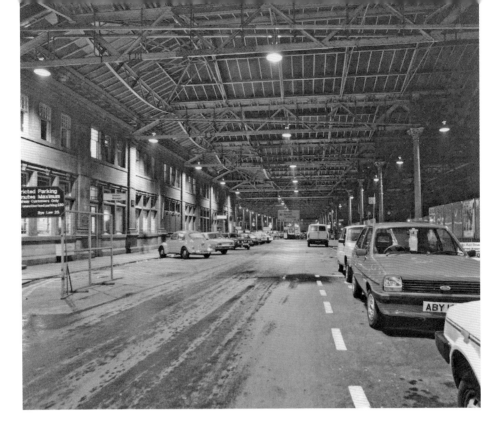

Dark and dismal, 1980s. This area is now used for taxi pick-ups. (William Dyer)

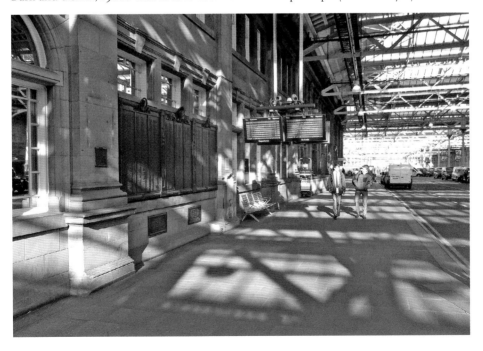

Clean and bright, 2014. The war memorial is on this wall to the left.

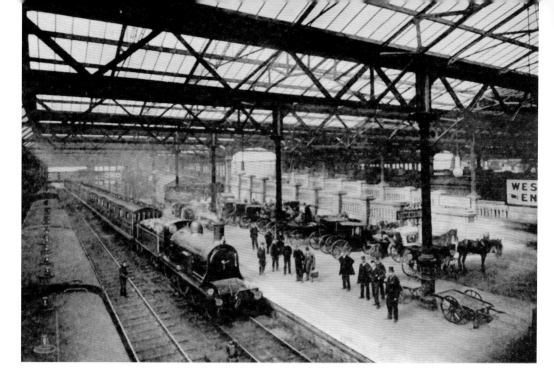

An old-style taxi rank. In the distance you can see a walkway featuring an advert for Oxo.

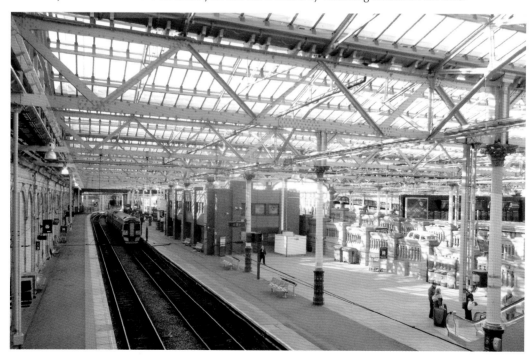

Same place, modern day. A new platform accommodates increased traffic. The platform area has been used for new admin buildings, and the new escalators completed in 2014 can be seen on the right.

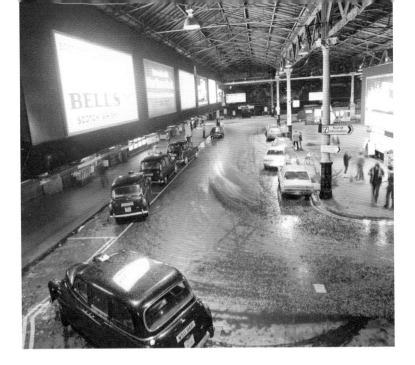

An early 1980s taxi rank. At that time, cars could freely enter, pick up or drop off, and then leave by the far ramp. It could be mayhem at times. (William Dyer)

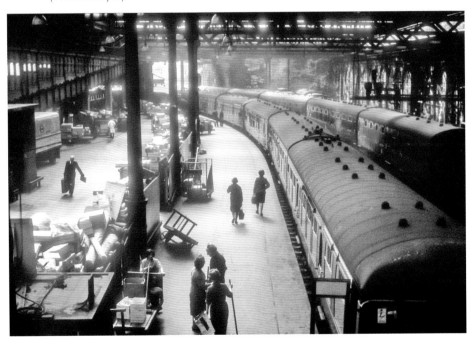

Waverley Station, 1966
Richard Friedman's lovely study of Platform 19 shows a wide range of activities, including the higgledy-piggledy state of the parcels depot on the left.

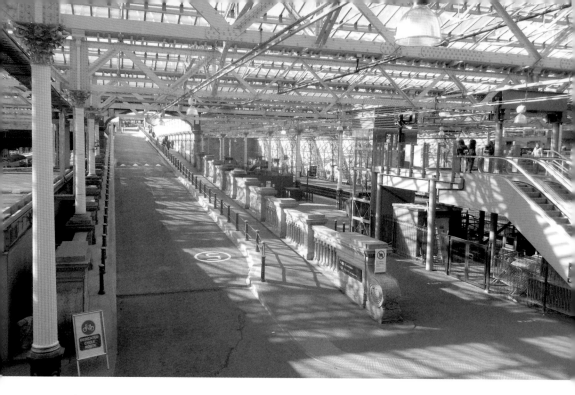

The view towards the same platform, No. 19, seen in 2014, a much brighter environment with new escalators. It is much less busy now, as private vehicles are excluded.

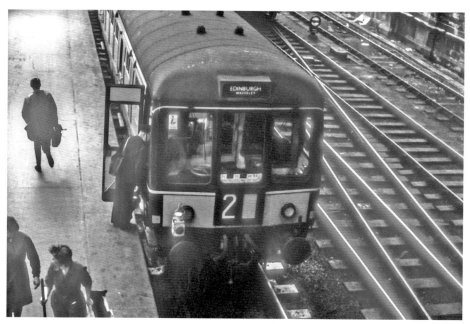

This grainy image of a Diesel Multiple Unit (DMU) arriving from Corstorphine was a slide taken by Richard Friedman in May 1966, the same month that fellow American Bob Dylan appeared at the ABC on his first 'electric' tour.

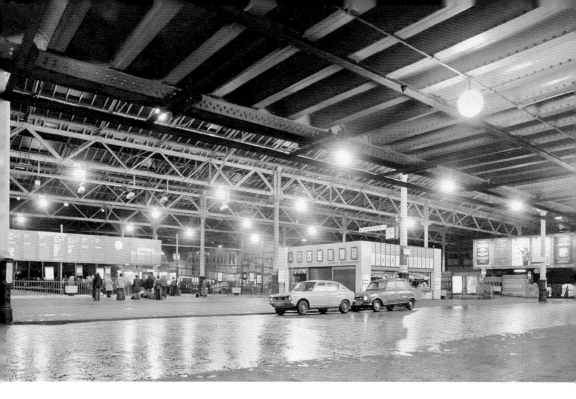

Dismal in the 1980s. (William Dyer)

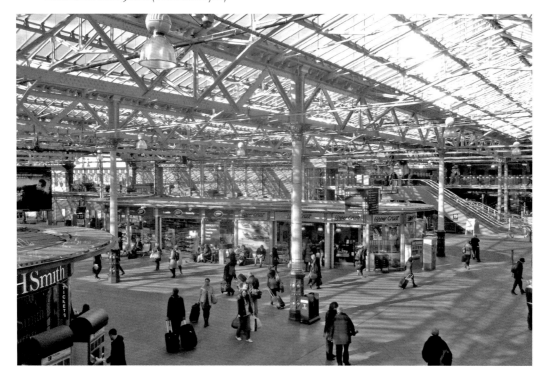

Nice and bright in 2014.

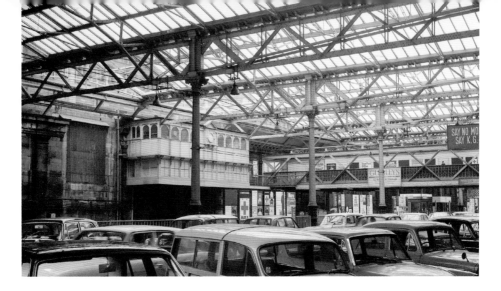

A signal box, which had been out of use since the 1930s, is seen here still in place around 1967. (Richard Hugo)

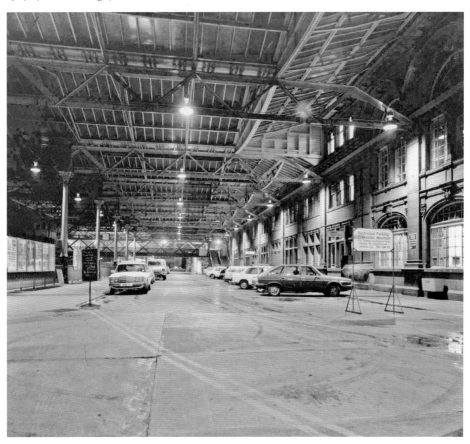

In the 1980s, parking was allowed, and the signal box is still there in the darkness, on the left. (William Dyer)

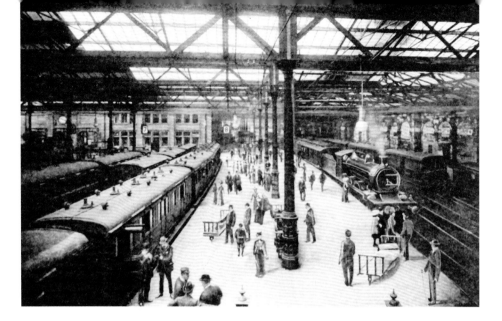

Trains leaving for the south and for the Borders. The luggage carts were very familiar on stations until replaced in 1964 by the British Railway Universal Trolley Equipment (BRUTE) seen below. These trolleys could be used singly, or linked together and pulled by a little electric tractor. They were often used for moving newspapers, mail and other goods. They went out of use in 1999.

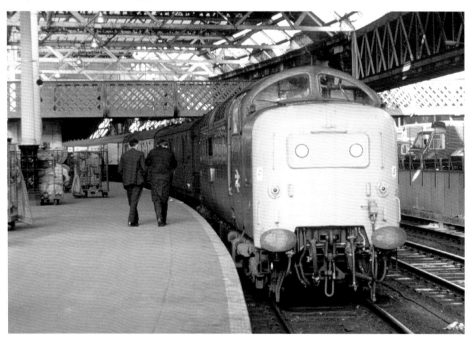

No. 55017 *The Durham Light Infantry* at Edinburgh Waverley, 23 August, possibly on its way to King's Cross from Dundee, since it did work that route around then. Railway staff used to look so relaxed. The enormous girder can be seen in earlier photographs. This allowed access to mail trains for post office vans, and directly from the General Post Office.

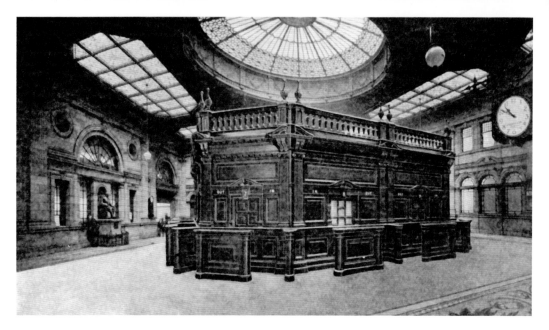

The elegant original ticket office with its glass cupola. This was in the centre of the station buildings. The statue has been removed, but it is possible it may have been Sir Walter Scott.

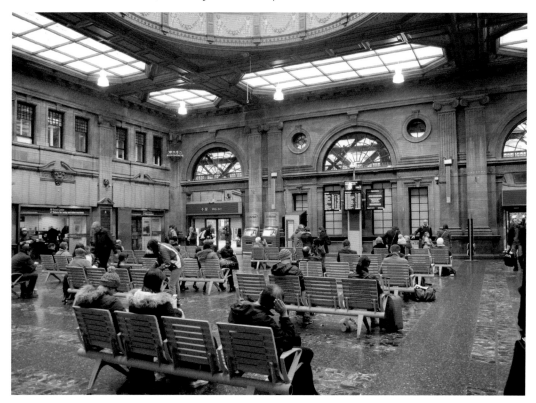

In 2014, this is now a waiting area with shops. The ticket office is on the left.

GUVs at the South Platforms
General utility vans (GUVs) were once a common sight in Britain's main railway stations, which also had parcels offices. GUVs were generally used for parcels and newspapers, although some had end doors and were used for transporting vehicles.

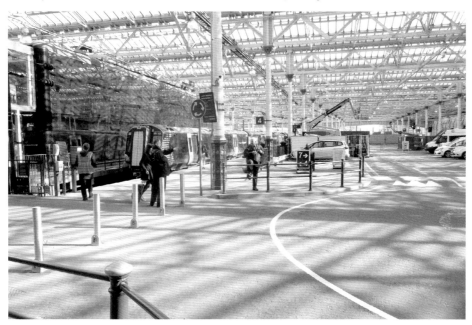

A more modern view of exactly the same area, showing the tasteful Operations Depot. Reflected on the glass walls is a Desiro Class 380.

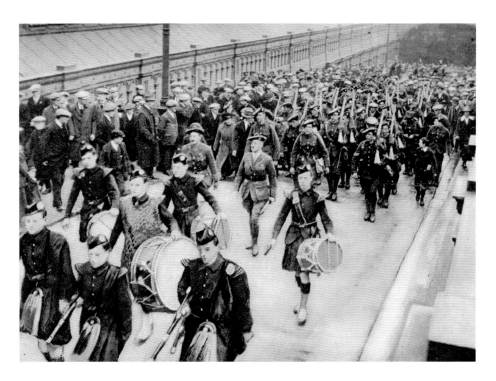

The arrival of the 4th Royal Scots in Edinburgh. (Campbell McCutcheon)

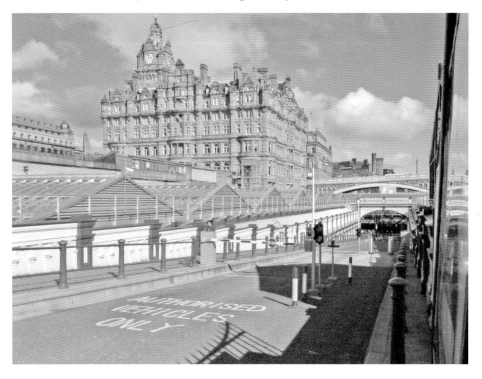

The station ramp.

Market Street.

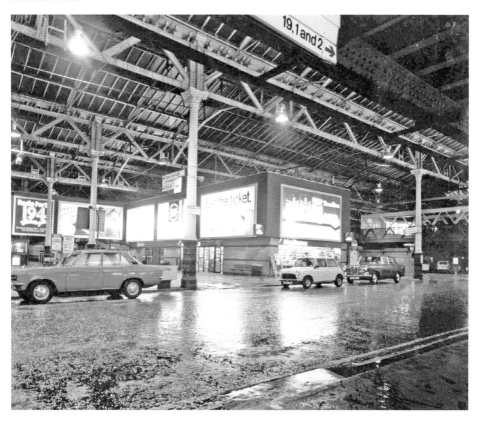

A very bright but wet concourse. (William Dyer)

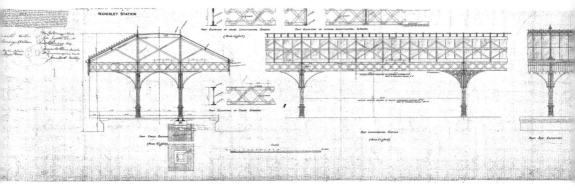

The design for the canopy. (Blyth & Blyth)

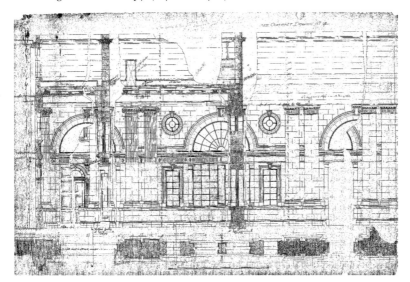

Architectural designs. (Blyth & Blyth)

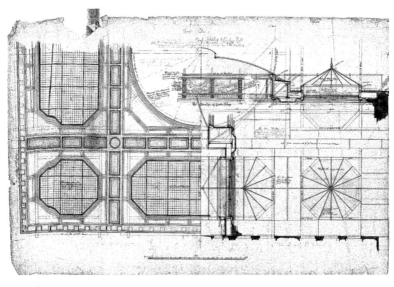

Architectural designs. (Blyth & Blyth)

The same area from the other direction; this is the newly modernised Calton Road entrance. On the right, you can see a wall between the pedestals; stairs went up from here to the Jeffrey Street crossing. There is an accessible drop-off point, and there is also to be a 'cycle hub' with secure cycle parking and lockers.

The pedestal for the walkway over the top of the station has now gone and the new roof is in place. However, a new accessible drop-off point has been constructed and will be an element in encouraging use of this underused entrance.

This is what emerged. (Colin Paterson)

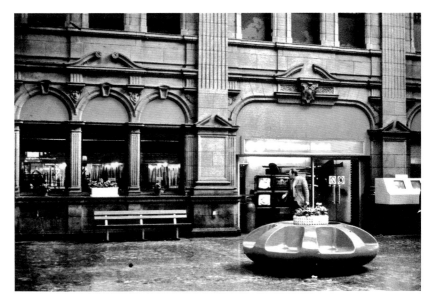

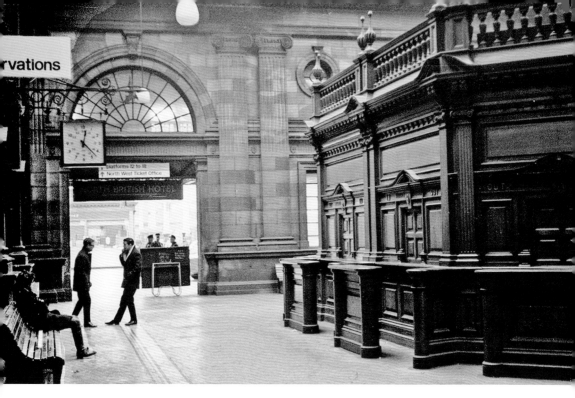

The station designs for the booking hall and original passage. (Colin Lourie)

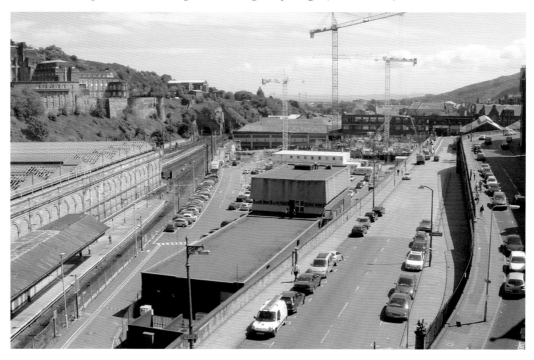

The goods yards have disappeared, and the new Edinburgh Council headquarters is going up. (Colin Lourie)

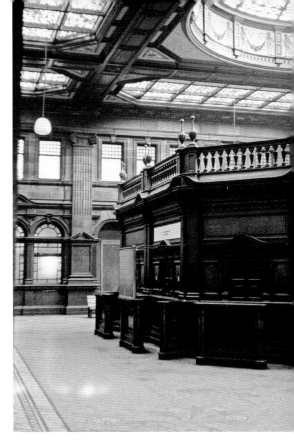

The booking hall on the day that it closed for demolition. (Colin Lourie)

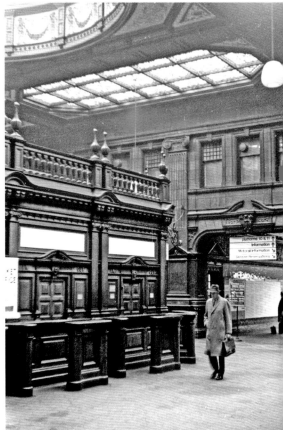

The station designs for the booking hall and original passage. (Colin Lourie)

The North British Station Hotel

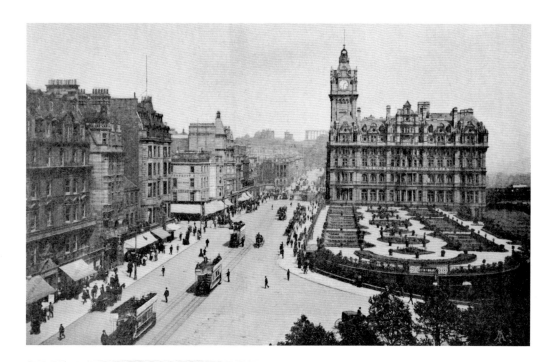

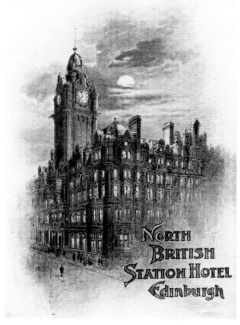

Above and left: North British Station Hotel.

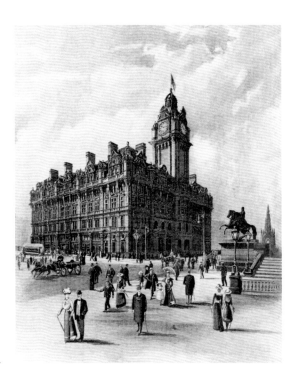

North British Station Hotel.

Throughout the Victorian age, nothing demonstrated the power and glory of commerce and industry better than the magnificence of the architecture, and none more so than the railway companies, who spared no expense showing how great they were.

In cities throughout Great Britain and the Empire, great railway stations and their railway hotels showed who was who: London's St Pancras, Manchester's Midland Hotel, Glasgow's Central and St Enoch's station hotels. They all competed to show which was the best and the biggest.

In Edinburgh, the opulent North British Station Hotel, opened in October 1902, was allowed as the only residential building south of Princes Street. The hotel, now called the Balmoral, was designed by William Hamilton Beattie, whose company was also responsible for Jenner's department store on the other side of Princes Street.

It was accepted that the hotel would not be profitable in the short term. The expense of building such a sumptuous hotel on a complicated site, along with the running costs, would take a long time to recoup. Just in terms of heating, the hotel was to consume 200 tons of coke a month.

Not only that, but plans had already been laid for another new, but competing, hotel on what was considered a better site. The Caledonian Railway's Princes Street Station Hotel was soon to open, and, being just as sumptuous, it would be a threat to the North British. This new hotel was to become the Caledonian – 'the Caly' – and was to survive the closure of the associated railway station; it still exists as the Waldorf Astoria Caledonian.

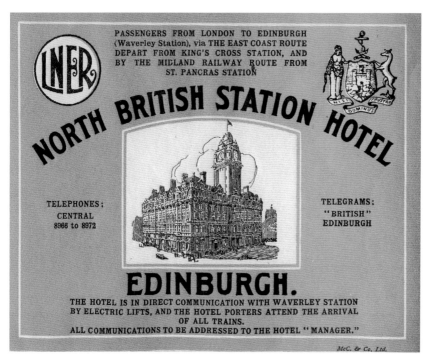

An original luggage label for the NB. The original name for the hotel was to be the Waverley Station Hotel.

These two hotels, just like the other railway hotels throughout Great Britain, were to be monuments to their railway company's ego and ambition. However, because of their generally central positions they have survived, mostly as prestige hotels like the Balmoral.

The NB was part of the 'Golden Age' of the railways but was also subject to the ups and downs of the industry. In 1922, with railway grouping, the North British Railway became part of the 'Big Four' and joined the London & North Eastern Railway Company. Following the Second World War, the railways were nationalised and so were the hotels. The LNER became part of British Railways in 1948.

With the coming of a Conservative government in 1951, Great Britain's fifty railway-owned hotels and associated infrastructure became managed by the British Transport Commission. In 1963, on the advice of Richard Beeching, chair of the new British Railways Board, British Transport Hotels was set up to manage the hotels independently.

During the tenure of the Conservative government from 1970, all new developments were stopped, and the portfolio of hotels was reduced. With Margaret Thatcher's Government from 1979, further privatisation took place. The BTH hotels were sold through public tender. By 1984, the offloading process was complete, with criticism from some quarters that the properties were undervalued at sale. The North British was sold in 1981 and as the 5-star Balmoral is now part of the Rocco Forte Collection of prestigious hotels.

This would be after 1956, as there are no trams in evidence; the last one departed in November of that year. (A. Hailstones)

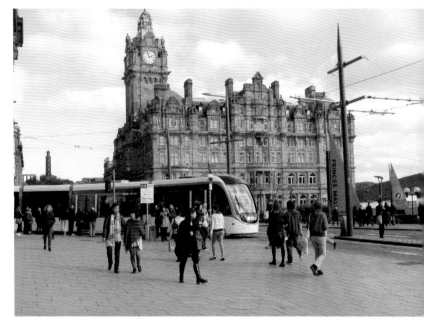

In March 2014, one of Edinburgh's brand-new trams makes an appearance on test.

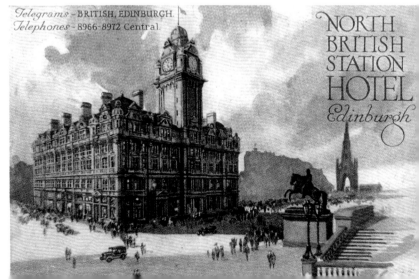

The magnificent North British Station Hotel.

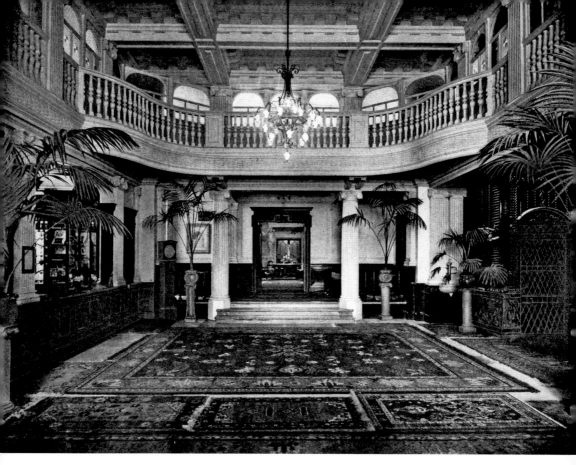

North British entrance hall in the 1930s.

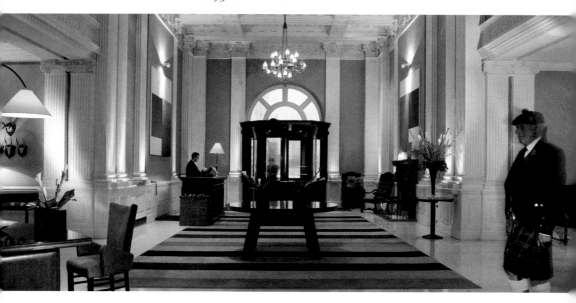

Balmoral Hotel reception and lobby, 2014. (Balmoral Hotel)

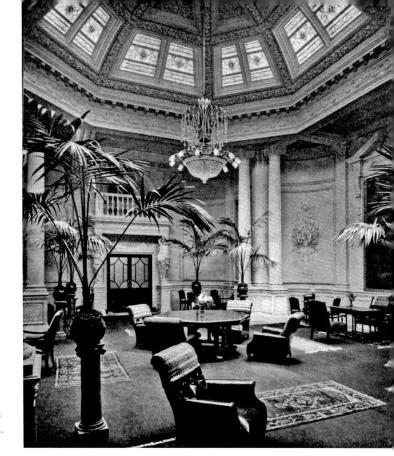

Right: North British Hotel in the 1930s.

Below: The Palm Court, seen in 2014. The style has generally been maintained. (Balmoral Hotel)

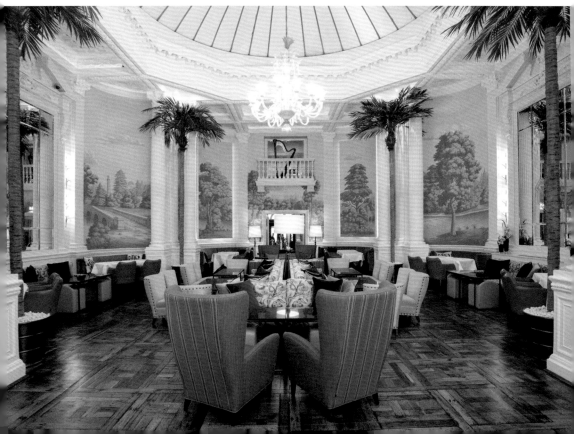

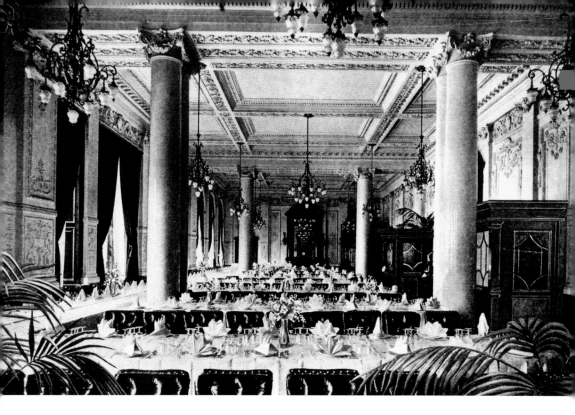

NB Hotel banqueting in the 1930s.

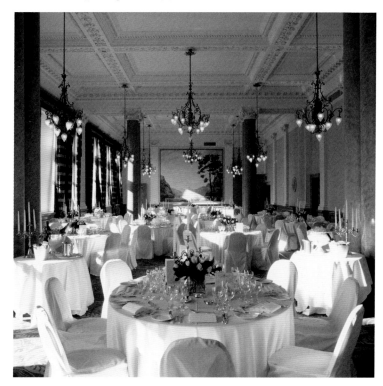

The Sir Walter Scott
suite, 2014.

This Way to the Trains

The North British Railway.

One of the joys of Waverley is that it is a hub. While many other city stations are at the end of the line, from Waverley the routes run north, south and west, some terminating and some running through from Inverness and Aberdeen to Euston, King's Cross and even Penzance.

A number of operating companies presently use Waverley; the largest, of course, is ScotRail, whose services encompass the Scottish mainland and connect with many ferry services to the islands. Their historic routes include Waverley–Dunblane, Inverness, Aberdeen and North Berwick. Routes to Glasgow include Waverley to Queen Street via Falkirk High. There is Glasgow Central via Shotts and Bellshill. A new route to Queen Street goes via Bathgate and Airdrie, going on to Balloch, Helensburgh or Milngavie. There is the Fife Circle going on to New Craighall and a more recent development is a train from North Berwick/Dunbar going forward via Carstairs to Glasgow Central, a lovely journey.

In fact the ScotRail routes have been constantly expanding, and as passenger numbers increase it is good to see the response in more destinations. The coming of the new Waverley Line will also see

increased traffic, particularly at the east end of the station. It has also been announced that there will be an exiting new service to Ayr, as an extension to the Carstairs route.

Also operating from Waverley is Virgin Trains to Euston via Birmingham. East Coast runs their high speed train (HST) service, running from King's Cross through to Aberdeen and Edinburgh. East Coast will be receiving the new Hitachi trains by 2016.

TransPennine Express operates from Waverley to Manchester Airport using Desiro Class 185 diesel multiple unit (DMU) and the new Desiro Class 250 Electric Multiple Unit (EMU). CrossCountry operates its Class 43 HSTs from Aberdeen to Cornwall, Great Britain's longest train journey.

The following pictures show some of these operating companies and their trains, as well as some of the historic routes associated with this great station. Where else would we start other than with that greatest of train routes, The Flying Scotsman? While we do that, we can see some of the developments within the station over the years.

The Route of the Flying Scotsman and the East Coast Main Line

The Flying Scotsman has run between London and Edinburgh since 1862, and at the moment is operated by East Coast. As we have already seen, the project to link Scotland and London involved the use of various railway companies' tracks as well as mergers and takeovers. The East Coast Main line (ECML) was eventually managed by three companies: North British, North Eastern, and Great Northern. In 1860, East Coast Joint Stock was established for through services, and from that emerged the Flying Scotsman, originally called the 'Scotch Express'.

From 1862, the Scotch Express departed both King's Cross and Edinburgh Waverley at 10.00 on a 10½-hour journey. In 1923, with the formation of the 'Big Four', Joint Stock became part of the LNER, and in 1924 the Scotch Express formally adopted its unofficial name, the Flying Scotsman.

An Edinburgh Waverley Flying Scotsman luggage label, designed by Frank Newbould.

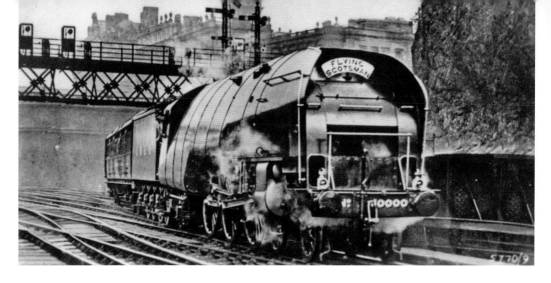

The Flying Scotsman, *c.* 1930
The Flying Scotsman, pulled by Nigel Gresley's streamlined W1, entered service in June 1930. This was an experimental locomotive with a chequered career. The work on it was kept so secret from competitors that it was informally named the 'Hush-Hush'.

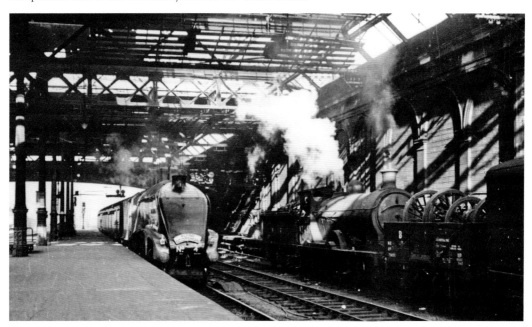

The Flying Scotsman is seen here, having arrived at Waverley in 1948. (H. C. Casserley)

This is a later version of the Flying Scotsman, which arrived from London King's Cross on 24 April 1948. Here the train is hauled by No. 4, *William Whitelaw*, an LNER Gresley A4 Pacific Class built at Doncaster and commissioned in 1937 at King's Cross.

Nearer the station wall is LNER Class D32 2451. This was one of ten built by the NBR at Cowlairs, and it went into use in January 1907 at Edinburgh's St Margaret's yard. It was withdrawn as 62451 in March 1951. It was obviously a workhorse in the Edinburgh area. By the way, the marking 'XP' denoted that this truck could be used in Class A express passenger trains. Their use as such was discontinued by British Railways.

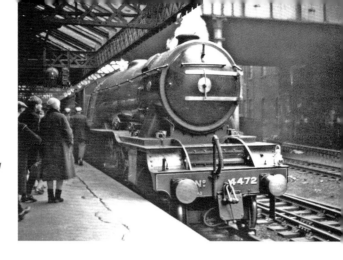

Preserved A3 Pacific 4472 *The Flying Scotsman*, named after the train route, has just arrived at Waverley, having travelled north over the Waverley Route from Carlisle, April 1966. (Mike Mather)

No. 4472, *The Flying Scotsman*, **in 1967**

No wonder there is interest. This is, again, *The Flying Scotsman*, No. 4472. This Nigel Gresley-designed Class A3 Pacific was built at Doncaster works in 1923 for the LNER, and used extensively on the route of the Flying Scotsman.

In November 1934, No. 4472 set a world record, becoming the first locomotive to be officially clocked at 100 miles per hour. It retired in 1963, but has been preserved in private ownership, and is now with the National Railway Museum. In retirement, it has toured in the United States and Australia and is considered by many to be the world's most famous steam locomotive. (Stephen J. G. Hall)

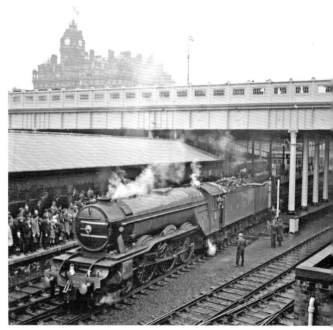

In 1969, a Deltic is seen about to leave Edinburgh Waverley with the Up Flying Scotsman. (Stephen J. G. Hall)

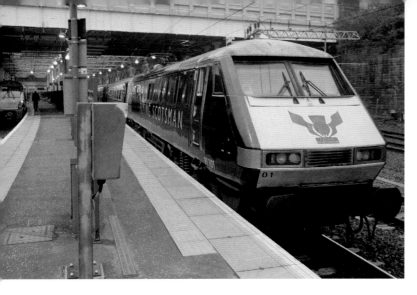

This photograph is right up to date, having been taken in March 2014. The East Coast Flying Scotsman has just arrived in Waverley. The Class 91, or InterCity 225s as they were named in the late 1980s, were electric locomotives which arrived as part of the East Coast Main Line modernisation.

While the Flying Scotsman was the most famous, there were other named trains. Among the other named trains were the Elizabethan, which was non-stop King's Cross–Waverley from 1953 to 1962, the Talisman from King's Cross to Waverley from 1956, and the Thames–Forth Express to St Pancras via Leeds, operated from 1927 to 1968.

The most recent development has seen specific trains 'wrapped' by East Coast. Unveiled in 2012 was Class 91 No. 91110, *Battle of Britain Memorial Flight*. The most recently 'wrapped' train was *Skyfall*, unveiled at King's Cross station in February 2013. Named after the James Bond film, the East Coast London–Edinburgh service train, No. 91007, had all of its eleven carriages covered in *Skyfall* artwork.

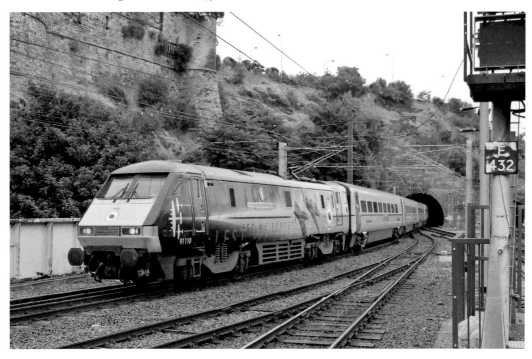

No. 91110, *Battle of Britain Memorial Flight*, arrives through Calton tunnel. (Mike Mather)

North British locomotive 770, a Holmes Class 729, built at Cowlairs, was introduced to Waverley in November 1899 and rebuilt as Class D31 in 1922. It was withdrawn in 1946. There was very little protection for the driver and fireman on these early locomotives.

In ScotRail Saltire livery, Class 156 No. 436 has just arrived from Dunblane. This 'Super Sprinter' is a DMU, one of 114 built between 1987 and 1989 by Metro-Cammel in Birmingham. These replaced 'first-generation' DMUs seen in other photos. The Edinburgh–Dunblane line through Falkirk and Stirling has been in existence since the mid-1800s.

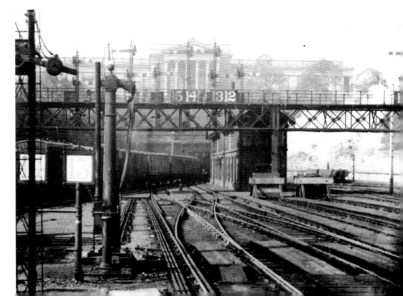

Taken by Robert McLaren, the uncle of Richard Casserley, around 1901, this image shows the signal box which once existed just beyond the westbound platforms.

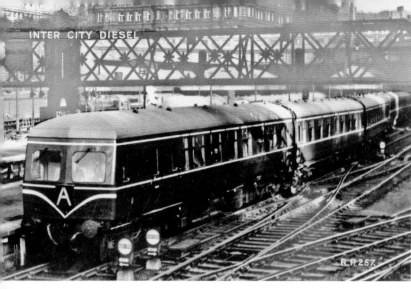

An Inter-City diesel multiple unit leaves Waverley for Glasgow Queen Street.

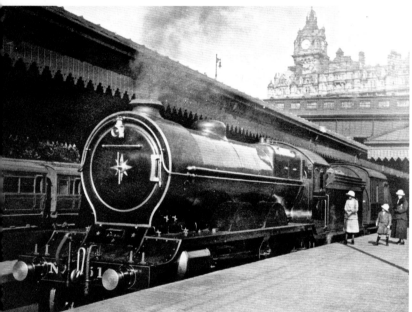

The Lord Provost
The Lord Provost, NBR 901, was a Class C11 Atlantic locomotive designed by William Paton Reid, who was locomotive superintendent at the NBR Cowlairs works, where he began life as an apprentice. The locomotive was built at the North British locomotive works and entered service in 1921, mostly working the Aberdeen route.

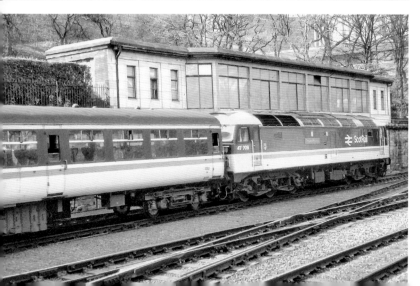

A much later *The Lord Provost*, No. 47709, with a 'Push-Pull', passes Waverley West box. (David Ford)

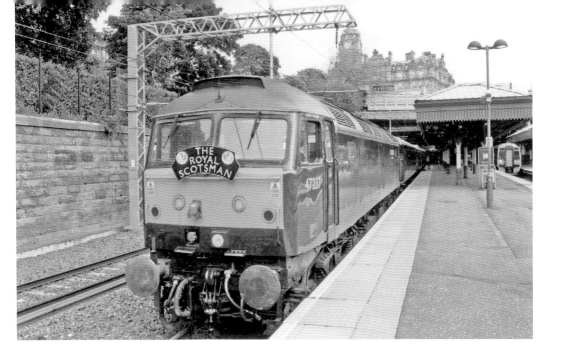

The Royal Scotsman, 11 June 2012, ready to depart for Keith.

The Royal Scotsman is a luxury charter train that regularly runs throughout Scotland. It has nine cars, comprising five state cars, two dining cars, a kitchen car and an observation car. The cars are all restored vintage stock. Here the train is pulled by Class 47 No. 47237, of West Coast Railways. (Alan Wass)

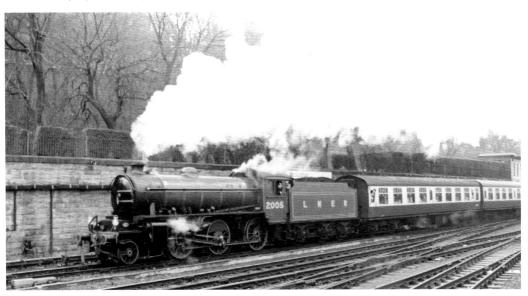

Pretending it's a lot earlier, LNER 2005 is seen at Waverley in December 1987.

LNER 2005 was designed by the LNER and built at the North British Locomotives Queen's Park works in Glasgow, before being handed over to BR in June 1949 as 62005. It was withdrawn from service in 1967 and subsequently bought for its boiler, but donated for preservation. This is actually a rail charter tour.

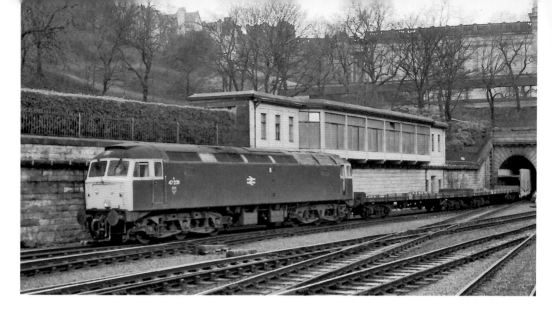

A couple of years earlier, 47231 is seen with empty car carriers on 12 April 1986.

This may be a car transporter related to the BMC/British Leyland plant at Bathgate. The plant closed in June 1986, although they did store cars there for a while. The plant was instrumental in keeping the Edinburgh–Bathgate line open to goods and then to passengers. This made the opening of the Edinburgh–Bathgate–Airdrie–Glasgow line a lot easier than it might have been. (David Ross)

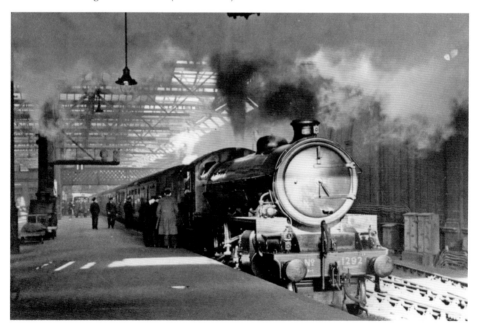

LNER E1292 at Platform 11 on 24 April 1948. (H. C. Casserley)

This is a Thompson Class B1 built by the North British Locomotive Company in Glasgow. It was taken into service at Thornton Junction on 25 February 1948, and allocated to Haymarket in March. Therefore, this image was taken very soon after it entered service. It was scrapped in 1965.

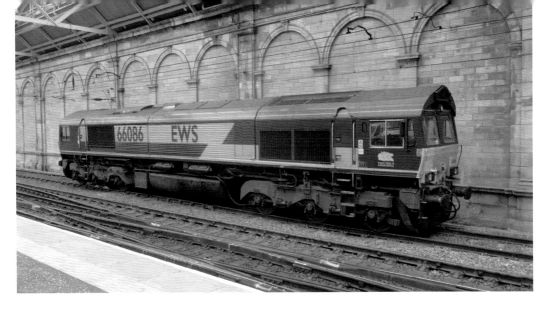

EWS Locomotive 66086 Resting Opposite Platform 11 in 2013

This is a Class 66 diesel electric locomotive, which has found some success in European markets. English Welsh & Scottish Railways, formed in July 1996, came about as an indirect result of the privatisation of British Rail. The emerging company, then known as North & South Railways, acquired Rail Express Systems, which included the Royal Mail contract. They then acquired Loadhaul Ltd, Mainline Freight and Transrail Freight. The amalgamated companies were then called English Welsh & Scottish Railways, or EWS for short. In June 2007, Deutsche Bahn AG acquired EWS and rebranded it as DB Schenker, a wholly owned subsidiary. DB Schenker's business concentrates on all forms of logistics, including air, rail, land and sea freight.

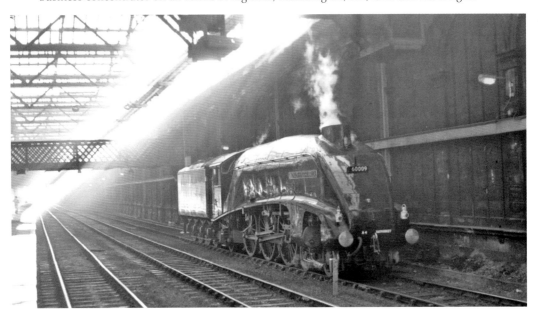

The *Union of South Africa*, 60009, sits alongside the Klondyke Wall in April 1981.

The Alaskan Klondike gold rush happened between 1897 and 1898, the exact time that the 2.3-metre-thick Klondyke Wall was built. (Arnie Furniss)

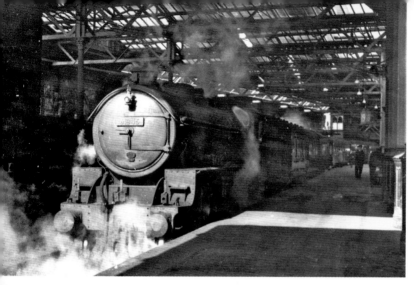

The 5.15 to Corstorphine is ready to leave Platform 19 on 19 April 1965. This is 61345, an Edward Thompson-designed Class B1 built at British Railways' Gorton works. It was withdrawn in July 1966. Corstorphine station was closed as part of the 'Beeching Axe' in 1969. (H. C. Casserley)

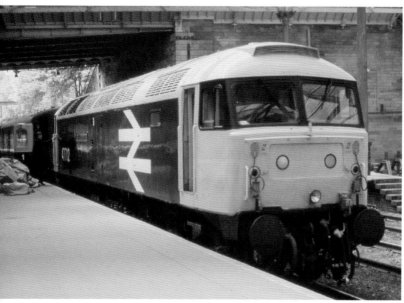

Eighteen years later, on 18 June 1983, the *Lady Diana Spencer*, Class 47, running number 47712, has arrived at Platform 19. No. 47712 has been preserved at Crewe Heritage Centre. The 47 was the largest class of diesel locomotives, with a total of 512 being built by Brush Traction between 1962 and 1968.

LNER 9767, a Holmes Class D31 which entered service in 1899 and was withdrawn in 1946 after forty-seven years of working. This is possibly the Glasgow Express, as it was one of the routes it worked.

We've moved Glasgow and Edinburgh 15 minutes closer together

This ingenious piece of time-and-motion applies only to the train, which zooms you between Glasgow and Edinburgh in only 43-45 minutes each way.

We've put luxury carriages on this run, but by the time you've relaxed—it's time to get off, and as there's a train every half-hour you won't have much time to hang about on the platform mulling it over. So you'll have to make a few trips before you get the feel of things. But believe us—things feel good.

When you travel this fast in luxury carriages, is it worth the strain of driving and the sweat of parking?

WHAT! THERE ALREADY!

Inter-City

It's just 43 minutes between Glasgow and Edinburgh.

Right: An Inter-City Advert. Forty-five minutes each way might surprise people just now.

Below: LNER No. 8473 is seen here at Waverley on 12 April 1946. (H. C. Casserley)

This is a Holmes LNER Class J83 (NBR Class D). Forty of the class were built between 1900 and 1901. It was used for shunting duties, and had a long life till replaced by diesel shunters in the 1950s. On the left is Gresley LNER 3667 Class V2, which was built in 1942 and withdrawn in 1966.

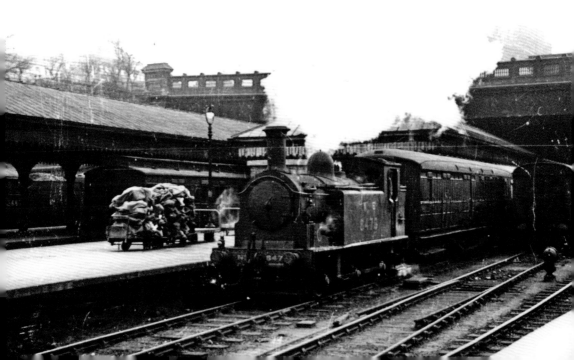

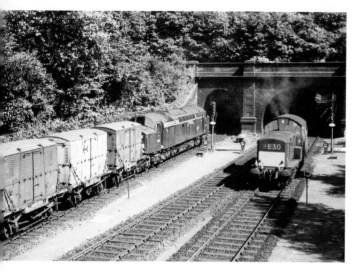

Diesels in the 1960s

About twenty-five years later, conversion from steam to diesel is well under way. In the background is a Class 37 hauling goods vans. The logo on the middle van was for the 'Door-to-Door' service which was introduced by the pre-nationalisation companies. In the forefront, a British Railways Class 17 diesel locomotive is working out of Haymarket. (Stephen J. G. Hall)

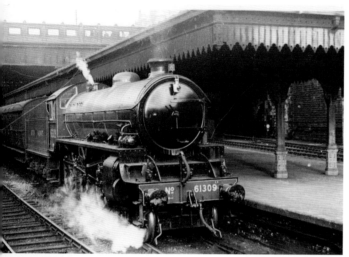

This is a brand-new Thompson Class B1 BR No. 61309, built by the North British Locomotive Company in Glasgow in April 1948. (H. C. Casserley) In fact this photograph was taken only ten days after it was delivered, on 24 April.

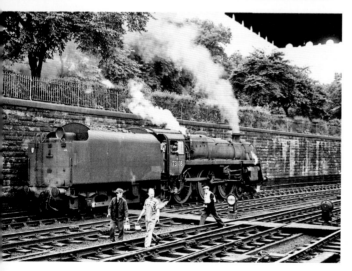

This is a Riddles Standard (or Britannia) Class 5, No. 73108, which was introduced in 1955, seen here at Edinburgh Waverley in July 1966. The BR Standard Class 5 was one of twelve standard classes built in the 1950s. A total of 172 were built between 1951 and 1954. This locomotive was withdrawn in 1966 from Carstairs. It is known to have worked from Hawick to Edinburgh. Maybe these lads are just coming back from giving the Forth Bridge a wee repaint? (Stephen J. G. Hall)

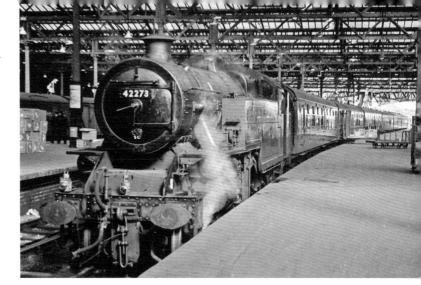

Fairburn Class 4P No. 42273, which was in service in 1947 and allocated to Dalry Road, Edinburgh, in 1948. It was withdrawn in 1966. The LMS Fairburn tank locomotives were designed by Charles E. Fairburn for the LMS. A total of 277 were built between 1945 and 1951. (Stephen J. G. Hall)

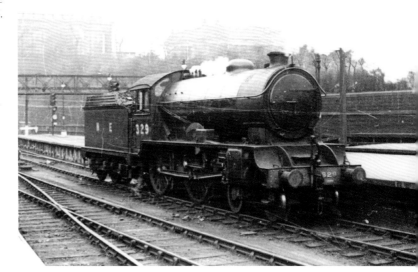

LNER 329 is seen here in April 1946. (H. C. Casserley)

This is a Gresley Class D49 4-4-0, *Inverness-Shire*. She was built in 1928 at the Darlington works, rebuilt as D49/1 in 1938 and withdrawn in 1958. The earliest of this class were called after shires throughout Great Britain, with later ones being given the name of fox hunts. I don't suppose that would happen now.

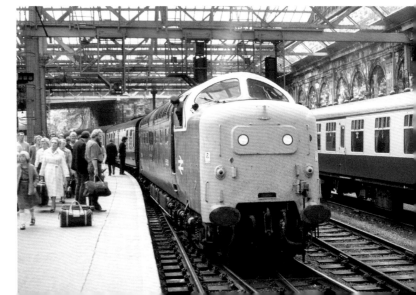

No. 55009 *Alycidon* arrived at Edinburgh slightly off platform! 31 July 1980. (Arnie Furniss)

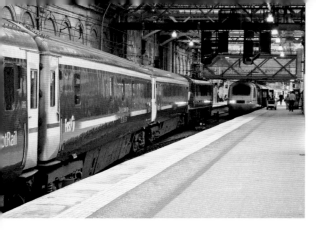

EWS Class 90 No. 90039 crosses over from Platform 2 at Edinburgh Waverley with the Caledonian Sleeper for Polmadie, and passes a waiting East Coast HST. (Mike Mather)

The Caledonian is one of only two sleeper services in Great Britain, the other being the Night Riviera between Paddington and Penzance. The Caledonian operates nightly, except Saturday, from Euston to Aberdeen, Edinburgh, Fort William (The Deerstalker), Inverness and Glasgow. The train comprises Mark 3 sleeping cars as well as a lounge car and a carriage with seating. The trains are pulled by DB Schenker locomotives.

From 2018, the Caledonian Sleeper service will be operated by Serco using new trains to be built by CAF of Spain. There will be a £100 million investment in rolling stock and carriages will include en-suite berths and pod beds.

While branded 'The Caledonian', it is clearly a number of separate routes and the last remaining in and from Scotland. Some people might think it surprising that, not so long ago, there were sleeper services from Inverness to both Glasgow and Edinburgh, using one train that split at Stirling, I think. Bear in mind, in the days before the current main road to the Highlands was opened, the journey to Inverness to Edinburgh could take five hours. The sleeper left Inverness at around 11 p.m., and you could arrive refreshed in the morning. I did that often, taking the ordinary service home in the evening. Inevitably, with the journey on the road reduced to two–three hours, the demand for the sleeper service dropped and it subsequently closed.

There was also, up to the 1990s, a sleeper service from Plymouth to Glasgow Central and Edinburgh: The Night Scot. The return journey was called the Night West Countryman.

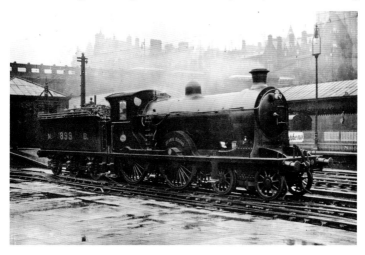

The *Jeannie Deans*, a D29 'Scott' Class
The second locomotive to bear the name, *Jeannie Deans* was one of six built by the North British Locomotive Company in 1909. Designed by William P. Reid for the NBR, they passed to the LNER in 1929, and *Jeannie Deans* was then renamed No. 9899. On railway nationalisation it subsequently passed to British Railways as 62404 and was withdrawn in 1949. It was based at the St Margaret's sheds, Edinburgh. The 'Scotts' worked passenger services from Edinburgh to Carlisle, Perth, Glasgow and Aberdeen, from where they also pulled fish trains.

Like many NBR locomotives, the name comes from Scott's Waverley novels. Jeannie Deans is a character in *Heart of Midlothian* and gave her name not only to railway locomotives but also to other things such as ships and pubs. The paddle steamer *Jeannie Deans* was a famous LNER steamer on the Clyde.

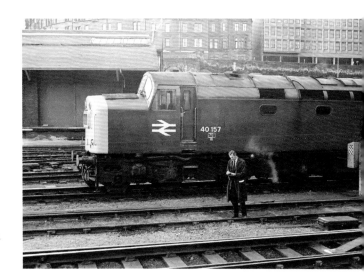

A study at Waverley in September 1976. No. 40157 is waiting to leave Edinburgh with a southbound Travelling Post Office (TPO). (Arnie Furniss)

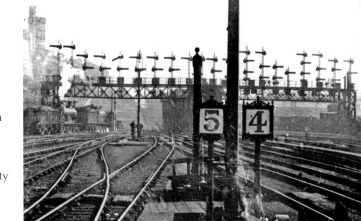

Waverley station, is seen here in 1901. (R. McLaren)

In this very early photograph taken by R. McLaren, uncle of Richard Casserley, the complexity of the signal gantry at the eastern approach to the station can be seen.

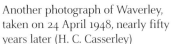

Another photograph of Waverley, taken on 24 April 1948, nearly fifty years later (H. C. Casserley)

Almost twins – LNER 8477 and LNER 8474, Holmes J83s by Sharp, Stewart of Glasgow, from 1901 – Nos 1962 and 1958 wait for work below the Scottish Office. They were based at St Margaret's. The signal gantry is still there, but bare. This is because signalling systems were developing as quickly as the trains. To reduce clutter and confusion, a system of ground signals was introduced for shunting operations. An example is in the foreground of the picture.

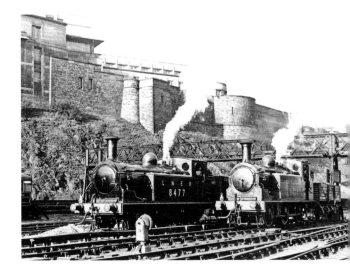

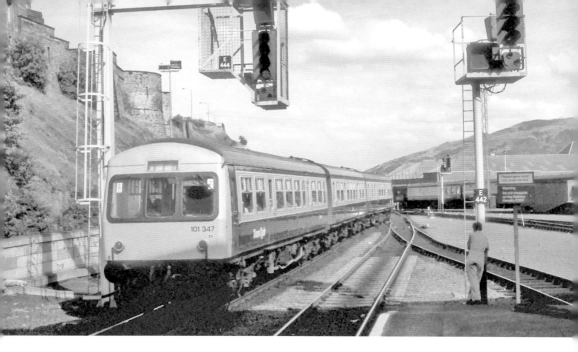

Class 101 No. 347 arrives at Waverley from North Berwick on 18 Aug 1987. The staff are just as relaxed! (David Ford)

Tank engine No. 10425 is seen here on 25 June 1927. (H. C. Casserley)

LNER Class D51 No. 10425 was built between 1880 and 1889 for the North British Railway as a Class R, and withdrawn in 1931. It was one of thirty designed by Dugald Drummond. These locomotives were used on local services around Edinburgh and Glasgow and on NBR branch lines.

Barclay Class 06 D2418 shunts at the east end of the station. The SMT bus garage is in the background. (Mike Mather)

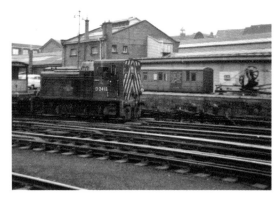

An Edinburgh Council building now sits in place of the building in the forefront. I think that is where we would go to buy trays of eggs on a Friday, from a railwayman with a secondary income. D2418 came into service at Kittybrewster in 1959 and moved to Leith Central in 1967 before being withdrawn in 1968.

Andrew Barclay was one of a small number of Victorian Scottish engineering companies that survived war, fire and flood to enter the twentieth century still making railway engines. While it is now under new ownership and currently refurbishes rolling stock, it is still a testament to the quality of what it has produced, particularly in the niche market of small locomotives.

Barclays, based in the Caledonia engine works, was set up by Andrew along with Thomas McCulloch in 1840 to manufacture mill and mining machinery. The company continued its success into modern times, acquiring, in 1930, engine makers John Cochrane of Barrhead, and when the North British Locomotive Company was in trouble they picked up the goodwill when it closed in 1963.

Another phase of the company began in 1972, when it was acquired by Hunslet of Leeds, which had also been a maker of steam shunters for over a hundred years. The name was changed to Hunslet Barclay in 1989. Following bankruptcy, the company was taken over by Brush in 2007, becoming Brush-Barclay, which was then taken over by Wabtec Rail in 2012. It continues with the refurbishment of railway stock at its Caledonia works.

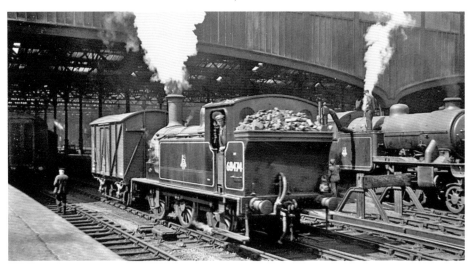

British Railways 68474 at Waverley, May 1953
Ex-LNER Class J83 68474 was a 0-6-0 tank locomotive designed by Matthew Holmes for shunting and short-distance work. Forty of these locos were introduced in 1900, made by Neilson & Co. and Sharp, Stewart & Co. No. 68474 was a Sharp, Stewart version, based at St Margaret's yard. She was cut up in 1958. She is moving a 10-ton ventilated goods van. This was all before the 1974 Health and Safety at Work Act!

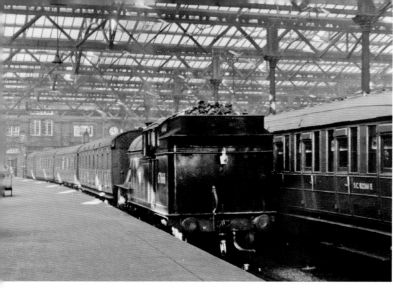

On 7 September 1955, Class V1 67666 is seen with passenger coaches. (H. C. Casserley)

The Class V1 was one of eighty-two designed by Nigel Gresley and introduced in August 1938. It seems to have been based at St Margaret's until its withdrawal in 1962. The V1s were first of all used on the Edinburgh–Glasgow and Helensburgh route.

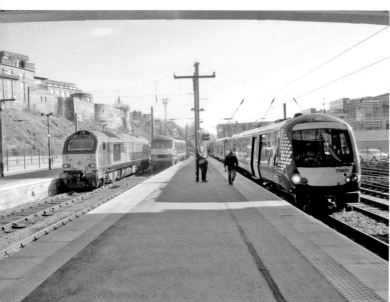

In March 2014, a train for Glasgow Queen Street waits to leave Platform 7.

It's a bit confusing to some passengers. Platform 7 is actually the same platform as No. 11. Both through platforms in the main station, this and platform 19/2, are effectively treated as separate platforms, with trains using points to bypass.

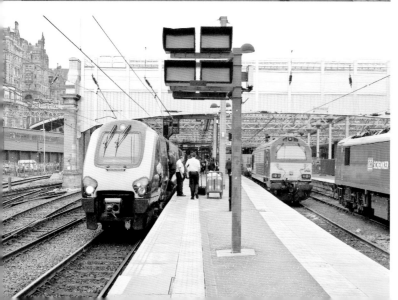

The CrossCountry Voyager has arrived at Platform 2 and sits alongside EWS 67008 and DB Schenker 90018. (Mike Mather)

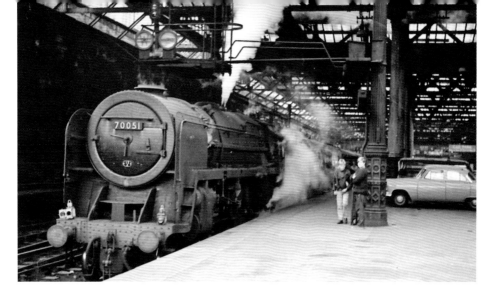

No. 70051, *Firth of Forth*
This is a Britannia Class locomotive, built at Crewe works and allocated to Polmadie in 1954. It was scrapped in 1968. (Stephen J. G. Hall)

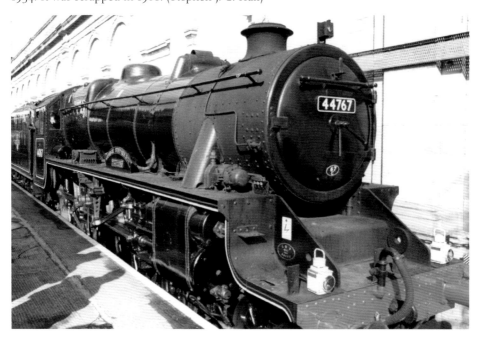

Preserved BR 44767 on a Visit to Waverley in 1985
The preserved steam locomotive *George Stephenson* was originally completed at the Crewe works on the last day of the LMS in 1947. It is a Stanier Black Five. *George Stephenson* is the name given to the restored locomotive, as it didn't have this in service. The locomotive was withdrawn in 1967 after only twenty years.

In total, 842 of William Stanier's informally named and highly successful Black Fives were built between 1934 and 1951. Eighteen are preserved. In preservation, No. 44767 has been a regular visitor to Scotland, hauling charters as well as the Royal Scotsman.

Prior to privatisation, this officers' saloon was used occasionally for official outings, this time pulled by steam locomotive *Union of South Africa*, No. 60009, owned by John Cameron, chairman of ScotRail. According to Mike Mather, who took the shot, this time it was a run up to Perth and back with the president of French Railways. It really looks very comfortable.

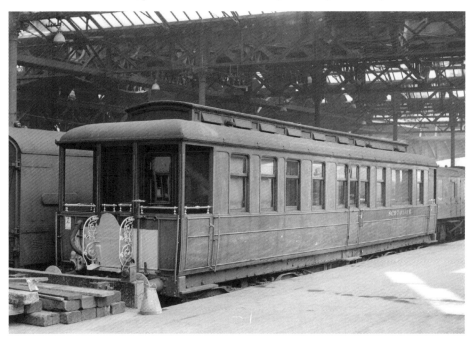

Magnificent! An inspection saloon at Edinburgh Waverley in 1966. Many railway companies had inspection (or officer's) saloons, which often had dedicated locomotives to haul them around, so that the railway directors could survey their domain (D. K. Jones collection)

The New Waverley

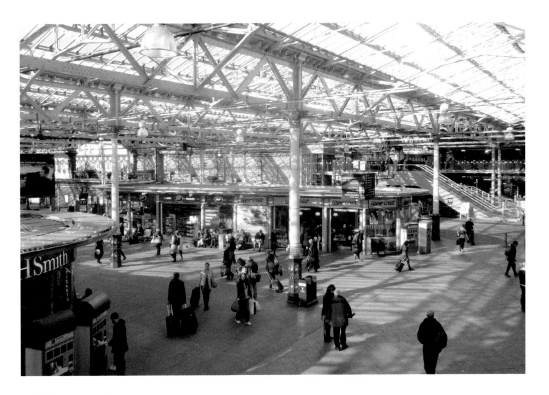

A bright new station emerges.

It is well known that in the days of British Railways and before, the railways suffered from a lack of investment. As you have seen from the photographs in the book, this lack of investment included the railway buildings: the stations, hotels and offices.

The cuts recommended by Dr Beeching in the 1960s were partly a response to the impossibility of managing and financing such a behemoth as Britain's railways had become.

While the denationalisation of railways was considered by many to be a politically driven initiative, there is no doubt that anyone now travelling on Scotland's railways will see modern stations and a generally well-kempt look. Indeed, with increasing opening and reopening of lines and stations, the railways are in a period of sustained growth, and are attracting ever more passengers.

It is apt that at the very heart of the renovated system are both Glasgow Central station and Edinburgh's Waverley, jewels in the crown of Scotland's national treasure: the railways.

The new Waverley Steps.

The investment to date in Waverley has been immense, and there is no doubt that it has been done well, and with minimum disruption to passengers and to travel. Waverley has come a long way since work started and there are ambitious plans for further work.

The developments over the past few years demonstrate the scale of investment; Platforms 12 to 18 were electrified for the new Airdrie–Bathgate link. This sounds innocuous enough but, to my delight when I saw it on the boards, it means that Waverley is now linked directly to Milngavie, Helensburgh and Balloch via Glasgow Queen Street low level. The new line, on the Bathgate & Coatbridge Railway, closed to passengers in 1956, has given access to stations in the old shale and coal mining areas of West Lothian and Lanarkshire. The towns of Caldercruix, Armadale and Blackridge now have access to Edinburgh and Glasgow. If you have the time then you can always cycle along the track that has been incorporated along the line. In fact, you can cycle from Edinburgh to Glasgow.

From 2010 and 2012 the glass roof was completely replaced with strengthened-glass panels, allowing the light to flood in, and you can look up to the magnificent Balmoral Hotel. The previous 34,000 m² of dirty glass and plastic sheets were removed, which has brought the bustling life below into the light and the twenty-first century.

Main Concourse, with the Balmoral Hotel Towering Above

You can see in the photographs that, alongside the through tracks at either side of the station, there were lines that were mostly used for bypassing or as sidings. These areas have now been converted to new through platforms. There had been plans considered for raising the entire concourse above

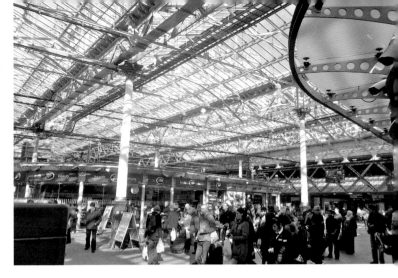

the platforms, which would be converted to through lines. Given the restrictions on building above the current level, and other considerations, these plans were scrapped. On the other hand, over the next couple of years, existing southbound platforms, currently used to stable waiting locomotives, will be extended to accommodate the new generation of trains ordered for East Coast. These will be Hitachi Class 800 Super Express Trains that will replace the much-loved but ageing fleet of Intercity 125 Trains. As this book is being prepared, Hitachi have announced that they are moving their train building operations to Great Britain.

The New Market Street Entrance

Perhaps the most eagerly awaited development among many is the reopening of the Waverley Route. The line was originally built by the North British Railway. It joined Edinburgh with Carlisle, running through the Scottish Borders. It linked Edinburgh with Hawick in 1849 and Carlisle in 1862. Along the way it took in many stops, including the large

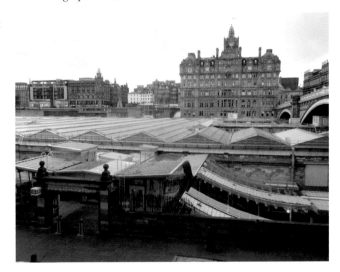

towns of Galashiels and Melrose. The closure under Dr Beeching was one of the most contentious and fiercely fought campaigns. It did close in 1969, but, after an unrelenting campaign, the line is once again going to come into its own, opening in 2015. The new line will have four new stations in Midlothian and three in the Borders.

If you lived in south Edinburgh you would know that ever since its closure, there have been similar feelings about the Edinburgh Suburban & South Side Junction Railway (or the South Suburban). The line opened in 1884, and, while freight services use the line, passenger services were withdrawn in 1962. The feeling is that the stations like Newington, Morningside and Craiglockhart would probably be used well by commuters. There is no doubt in my mind that this will eventually happen.

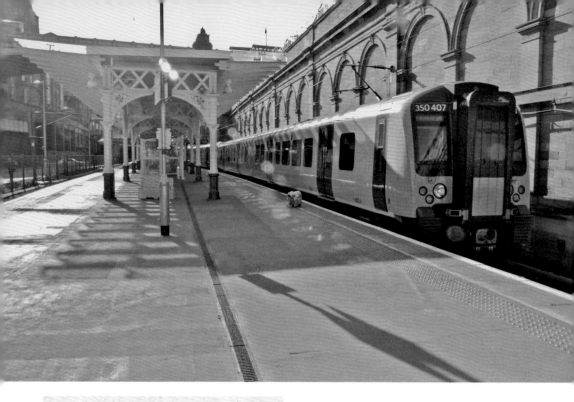

BRITISH RAILWAYS B32006

DIESEL TRAIN SERVICES
and
CHEAP TRAVEL FACILITIES

BLACKFORD HILL	GORGIE (East)
DUDDINGSTON	MORNINGSIDE RD.
CRAIGLOCKHART	NEWINGTON

WITH

EDINBURGH (Waverley)
and HAYMARKET
11th SEPTEMBER 1961 to 16th JUNE 1962
(or until further notice)

Further information can be supplied on application
to stations, accredited Rail Ticket Agencies, or
J. K. Cumming, District Commercial Manager,
23 Waterloo Place. Edinburgh, Telephone No.
WAVerley 2477.

TRAVEL BY TRAIN

Notice as to Conditions :—Tickets are issued
subject to the British Transport Commission's
published Regulations and Conditions applicable to
British Railways, exhibited at their Stations or
obtainable free of charge at station ticket offices

This Class 350 (without branding) has arrived from Manchester Airport and sits at what were the South Suburban Line platforms (the South Sub). On the far left, there was a yard and sidings, partly under what is now the Fruitmarket Gallery. Above were fruit and vegetable market buildings, including what is now the City Art Gallery in Market Street. The brand new Siemens Class 350 Desiro, operated by First TransPennine Express, came into service in December 2013.

1960s advert for the Edinburgh South Circular.

The new Market Street
entrance, crossing the South
Sub platforms and the old
Fruitmarket sidings.

The Renovated South Sub Platforms

There were once workshops
in the middle of the platform
(where I was based). The
buildings at the far side were
workshops, now unused. These
were below an enormous water
tank, which has only recently
been removed.

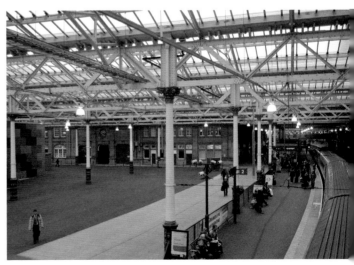

**The uncluttered east end of
the station, where we will see
a new café culture. I can't wait.**

Another new, exciting
development will see the east
end of the station come out of
the doldrums and become the
venue for its own café court with
statues and plants. It will have
an experimental weekly market
selling local and ethical goods.

These new developments
herald an exiting time for the
station and the city. It will be
interesting, too, to see the east
end of the station become alive.

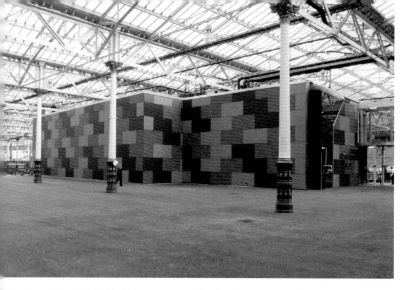

Operations depot.

Walkway.

The rear of the main
building.

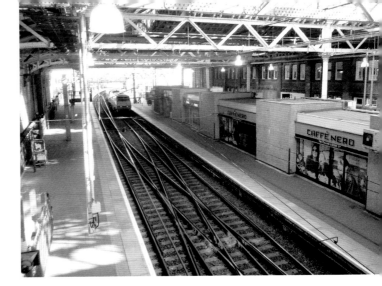

Caffé Nero, Platform 19/2, with the new platform on the left.

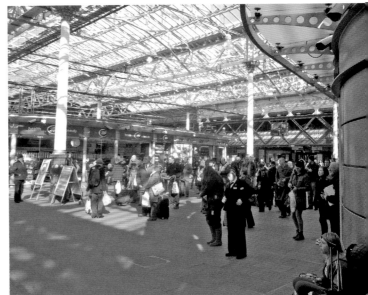

The concourse.

The concourse.

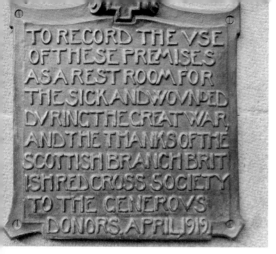

TO RECORD THE VSE
OF THESE PREMISES
AS A REST ROOM FOR
THE SICK AND WOVNDED
DVRING THE GREAT WAR,
AND THE THANKS OF THE
SCOTTISH BRANCH BRIT
ISH RED CROSS SOCIETY
TO THE GENEROVS
DONORS, APRIL 1919

The British Red Cross plaque.

A column.

The war memorial.

The North British crest.

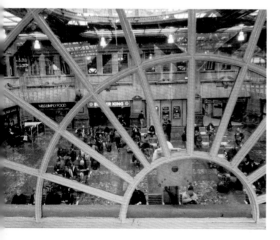

Through the round window.

The North British Railway Logo.

The plumber's shop, one of the last vestiges of the number of trades once employed at the station.

Column detail.

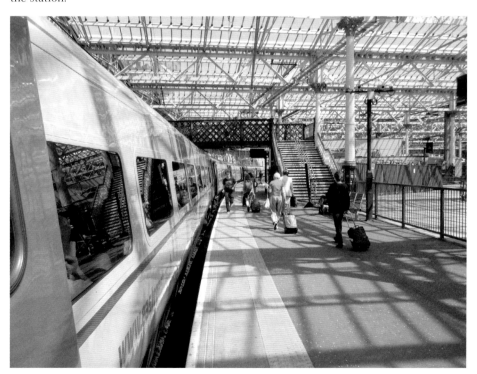

Calton Road entrance.

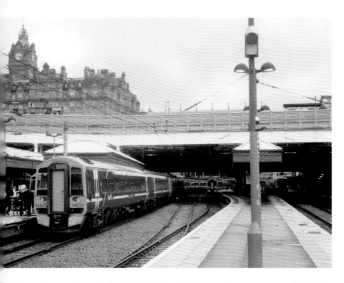

A Class 158.

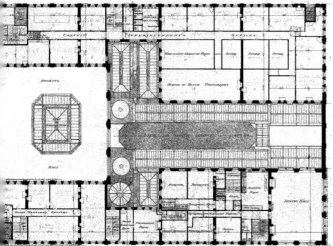

Drawing of the Waverley building, first floor. (Blyth & Blyth)

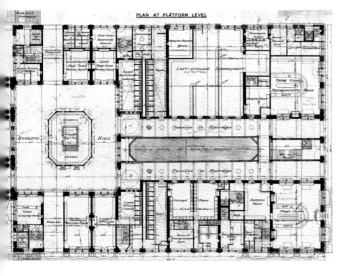

Drawing of Waverley building, ground floor. (Blyth & Blyth)

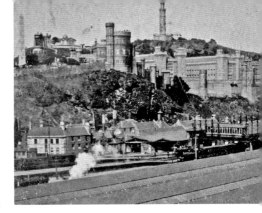

A view looking towards Calton Hill.

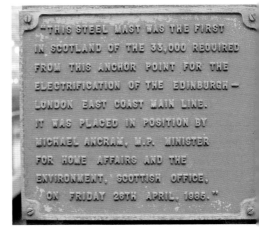

An electrification plaque, 1985.

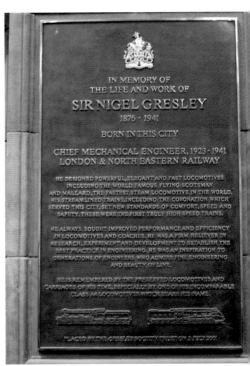

The Sir Nigel Gresley plaque.

The East Coast service from King's Cross has arrived.

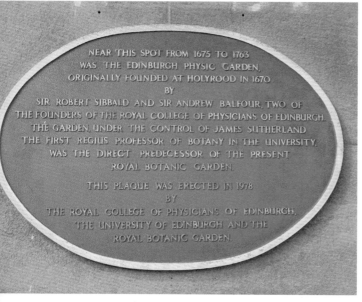

NEAR THIS SPOT FROM 1675 TO 1763
WAS THE EDINBURGH PHYSIC GARDEN,
ORIGINALLY FOUNDED AT HOLYROOD IN 1670
BY
SIR ROBERT SIBBALD AND SIR ANDREW BALFOUR, TWO OF
THE FOUNDERS OF THE ROYAL COLLEGE OF PHYSICIANS OF EDINBURGH.
THE GARDEN, UNDER THE CONTROL OF JAMES SUTHERLAND
THE FIRST REGIUS PROFESSOR OF BOTANY IN THE UNIVERSITY,
WAS THE DIRECT PREDECESSOR OF THE PRESENT
ROYAL BOTANIC GARDEN.

THIS PLAQUE WAS ERECTED IN 1978
BY
THE ROYAL COLLEGE OF PHYSICIANS OF EDINBURGH,
THE UNIVERSITY OF EDINBURGH AND THE
ROYAL BOTANIC GARDEN.

A 'Physic Garden' was once where the east end of the station is now.

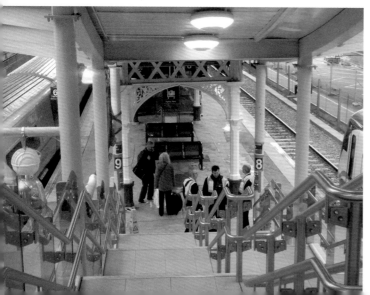

Down to platforms 8 and 9.

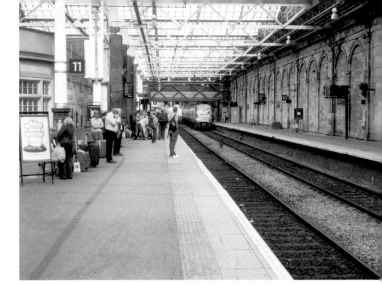

Platform 11 and the new Platform 10.

Scotrail in Princes Street Gardens.

Scotrail in the gardens.

The British Rail double arrow has been retained as a sign indicating a railway station.

The Grill Room.

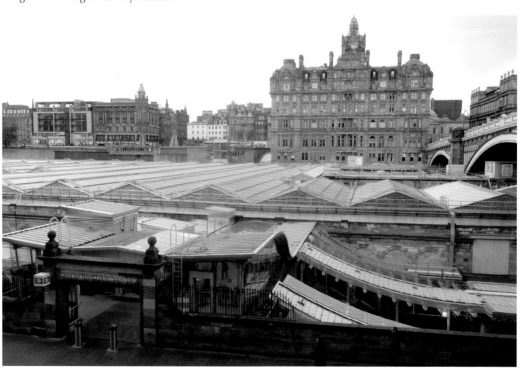

The new Market Street entrance.

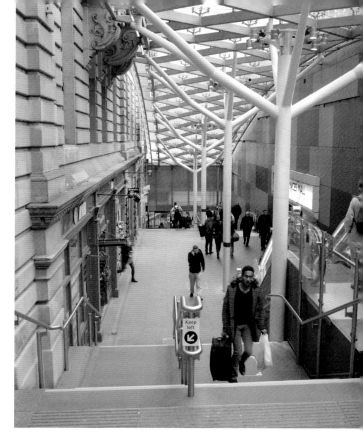

The Waverley Steps.

Ticket machines have been introduced.

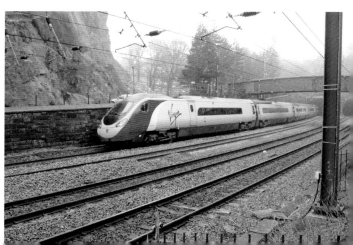

Virgin Rail in Princes Street Gardens.

Acknowledgements

In completing this book, I have been able to draw on the goodwill of many railway and architectural enthusiasts, and I am very grateful to them for allowing me to use their images and for preserving Edinburgh culture.

I am particularly indebted to Mr R. M. Casserley for a range of wonderful black-and-white images. Also to Adrian (Mr Evil Cheese Scientist), Luke Bryant, Jim Carter, D. K. Jones Collection, William Dyer, Edinphoto, David Ford, Richard Friedman, Arnie Furniss, Alan Hailstone, Stephen J. G. Hall, Alex Hogg, John Law, Keith Long, Mike Mather, David McKelvey, Richard Hugo, Steve Stadalink, Sixties Edinburgh, Stephen Monaghan, Michael Patterson, David Ross, A. G. Thoms, and Alan Wass.

Thanks go to Stewart Macartney and Blyth & Blyth for their support, and use of their wonderful images.

Thanks, too, to Juliet Donnachie, Station Manager of Waverley, and her staff for the amazing support. ScotRail staff have also been helpful.

Further thanks go to Carlton Hotel Edinburgh; Helen Henderson; John Cameron, past Chairman of ScotRail; Kyloe Restaurant; The Rocco Forte Balmoral Hotel; St Christopher's Inn.

The following websites have been useful:

Electric Scotland
The London & North Eastern Railway (LNER) Encyclopedia
The brdatabase
North Eastern Locomotive Preservation Group
Rail UK
North British Railway Study Group